PHOTOGRAPHING YOUR CRAFTWORK

CRAFTS REPORT BOOKS

The Law (in Plain English)[TM] *For Craftspeople*
 Leonard D. DuBoff
Business Forms and Contracts (in Plain English)[TM] *For Craftspeople*
 Leonard D. DuBoff
Profitable Crafts Marketing (paper)
 Brian Jefferson
Photographing Your Craftwork
 Steve Meltzer

PHOTOGRAPHING

YOUR

CRAFTWORK

A Hands-On Guide for Craftspeople

STEVE MELTZER

A Crafts Report Book

INTERWEAVE PRESS
COPELAND PRESS INC.

TO DIANE

Published by
INTERWEAVE PRESS/COPELAND PRESS INC.
P.O. Box 1992
Wilmington, Delaware 19899

Library of Congress Cataloging-in-Publication Data

Meltzer, Steve.
 Photographing your craftwork: a hands-on guide for craftspeople / Steve Meltzer.

 p. cm.
 Originally published: Seattle : Madrona Publishers, 1986.
 Includes index.
 ISBN 0-934026-81-5 : $12.95
 1. Photography of handicraft. I. Title.
TR658.5.M45 1993 92-35819
778.9'7455 — dc20 CIP

All material here first appeared in *The Crafts Report*

Sketches by Paul Lewing

Photos by author

Craft pieces shown in this book are copyrighted by Jean Griffith, Elly Smith, David Lesser, Stoner Pottery, Paul Lewing, Jon Simmons, Lou Scorca, Leslie Liddle, Judith Meltzer, Walter White, and Ulla Winblad-Hjelmquist

Preface

THIS book was a long time in coming. It began over five years ago as a series of monthly how-to-take-pictures columns and has grown with time to cover much, much more.

This is for craftpeople who find that they *must* have good photographs of their work for shows, fairs, and galleries. That includes just about everyone who does craftwork, from the amateur needlepoint artist to the professional jeweler with a business grossing six figures. Photography is the way that crafts enter the field of communications. From magazines and newspapers to slide shows, photography allows crafts to reach large audiences of potential customers.

When I began writing the columns I sought out what other books and articles I could in the library. There was little existing material. But that's reasonable, considering that crafts photography as such hasn't existed very long.

Prior to the 1960s there wasn't all that much interest in crafts. There were few working craftpeople and, since most commercial photographers could shoot the occasional photo for a newspaper ad, there wasn't any need for "crafts photography."

That all changed in the '60s, and over the next twenty years there was a phenomonal growth in crafts. Suddenly hundreds of craftspeople were trying to get into shows and fairs and suddenly everyone needed slides or prints of craftwork.

But while writing the columns I found that the need for information went far beyond simple how-to-take-a-photograph instructions. Craftspeople asked about everything from dealing with photographers to the best buys in used cameras. The

subject matter of the columns expanded, and after five years and over fifty columns I found myself looking at the basic text for a book.

I think this is a pretty unique book. It covers so many areas of photography that — whether or not you are going to shoot your own photographs — it can be a valuable reference and aid to your craft.

It is also biased. The methods and materials I've described are ones that I've used, and I'm clear about my preferences as to film, cameras, and techniques. I hope you will take my suggestions, try them, and modify them to your own needs.

But, even if you're following my directions to the letter, you may not get perfect results at first. You will waste some film and some time and make some mistakes. Don't panic; it takes a little practice. And I've included a lot of information to help you troubleshoot. You should be able to find out how to correct your mistakes and, perhaps more important, find out how to recognize mistakes. Being able to recognize a good photograph is the first step in taking good photographs.

With a little time and practice your photographs will improve markedly.

This book was improved markedly through the efforts of Mike Scott at *The Crafts Report* and Sara Levant of Madrona Publishers, who helped to keep this work on track and helped a photographer to be a writer.

Contents

PHOTOGRAPHING YOUR CRAFTWORK

1

Photography from a Juror's Point of View

TELEPHONES demand to be answered. Since I'm a photographer, mine invariably rings when I'm in the darkroom. Usually I'm counting seconds for a particularly tricky bit of photo printing. I was up to the twelfth second of a sixteen-second burn when my phone rang one day in February.

I lost track of my count at the second ring and, mildly cursing, picked up the phone.

"Hello," I said, trying to cover my annoyance.

"Hi. Is this Steve Meltzer?" asked a strange voice.

"Yes," I said, making little happy faces in my voice. After all, this might be a new client.

"Well, I'm with an arts commission and I'm the director of visual arts and I'd like you to jury our Visual Arts Fellowship applications."

I hesitated for a moment to get my mind off the messed-up print and onto this new track. My caller took this pause as caginess on my part.

"We'll pay you an honorarium, of course," she added, baiting the hook. My voice began to be downright bubbly.

"That sounds wonderful. I'd love to be a juror. What do I have to do?" I said, covering up the fact that for the right price, I'll do almost anything.

And so it came to pass that a package of some fifty applications and their accompanying photographs was delivered to my door by the U.S. Postal Service.

The package was fairly large and wrapped by people who clearly understood the Post Office's gentle touch. I placed the package on my dining-room table and began to unpeel it slowly, gently. This was serious business. Based on my selections and the choices of two other jurors (whose names were kept from me), four visual artists would receive fellowships of $5,000 each. This was the big time. Right up there with the Oscars. Careers were on the line. I could be helping the next Picasso or Soldner or even a Warhol get started.

But there was a more personal level to being a juror. For over five years I'd been trying to explain photography to crafts-people in the pages of *The Crafts Report*. I had also shot the work of dozens of craftspeople myself, and now I was on the other side. Now I'd find out what a fairly random sample of craft slides would look like. Was it true that good slides were impor-tant? Would pure talent shine through even in the lousiest pic-tures? Would professional pictures be better than the actual craftwork itself?

The stack before me on the table contained hopes and aspirations. I decided that for my first look I would simply view each slide sheet and try to get a sense of all the work. No names,

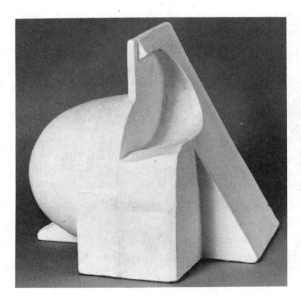

A photograph that would attract any judge's attention. Because this ceramic piece is all white, lights were used to create shadows to emphasize the planes. (Artist: Jean Griffith)

no peeking at resumés or applications. Just a visceral scan. I wanted to react to the images directly.

One at a time I viewed the slide sheets.

There were slides showing ceramics, photography, jewelry, weavings, scultures, paintings, drawings, and mixed media. The variety was enormous. The slides themselves ranged from superb to horrendous. Some were out-of-focus duplicates, some were washed-out overexposures, and some were too dark. I was shocked by these poor-quality slides. Even if I wanted to select one of these applicants I was put off by the slides. I couldn't really tell from the bad slides what the work was like.

"Okay," I thought to myself, "give them the benefit of the doubt. Let's not drop anyone yet."

So I went through the applications again. This time I read each application, each resumé, and looked at the images again.

QUALITY OF CRAFTSPEOPLE'S SLIDES

What I found this time around was even more surprising. Lots of the applicants with terrible pictures were associated with universities while, generally, the working craftspeople and artists had the better slides. Actually, that isn't all that surprising since working craftspeople *have* to sell their work and (if I may note with a bit of pride since I preach it regularly) were learning that the photographs of their work are very important for business. University folk probably don't have to face the same daily rigors of the real world of economics and competition, and therefore haven't figured out the importance of quality images of their work. At least that's the impression I got from my random sample of fellowship applications.

The other interesting thing I discovered was that there wasn't any correlation between craft experience and quality of slide. Several individuals whose resumés indicated that they were young artists in their twenties had the best photos (with one terrible exception); several applicants with long resumés and careers that spanned a decade or two offered slides that were mediocre at best.

You might be asking, "What about the photographers; didn't they have the best slides?"

Well, no, they didn't.

Several of the photographers had sent slides of their black-and-white photos, and these were generally acceptable but nothing remarkable. Some worked in color, and their slides were apparently duplicates of their original work. None of these were very good, either technically or in content.

But after going through the stack a second time I was still reluctant to drop anyone from the running. Instead, I sorted the applications by medium and tried to get a sense of the work by comparison with similar work.

This time the quality of the slides really came through. And this time I began to make a pile of rejected work.

From the original fifty I got down to fifteen, and I needed to select four. Not bad by the third cut.

THE MORAL OF THE STORY

At this point you might be wondering what this all has to do with juried craft shows such as the ones you enter, in which there are hundreds of applicants, and jurors screen slides for about fifteen seconds each.

Although you may reasonably moan at the injustice of the universe, the point is that to survive in a competitive marketplace one *cannot* afford bad photography. Whether you are producing a small ad for a magazine, sending out a show announcement or entering a competition, the quality of your photographs says a great deal about how much you respect your own work. This came through very clearly in my stack of fellowship applicants. Although I didn't eliminate an application *simply* for poor photography, I found that if I was in doubt about a particular applicant the quality of the slides became a factor. In such cases, poor photographs meant the applicant was eliminated, while well-done photography kept the applicant in the running.

For my fourth review of the applications I took my fifteen remaining sets and reread the applications, resumés and supporting letters. I had decided these were the works I liked and now I wanted to get more of a sense of the people behind the crafts.

The fellowship was supposed to be awarded to visual artists who were at a midpoint in their careers. The notion was to be able to use the awards to make a significant difference in an artist's creative life. To provide a few months of relative freedom from financial concerns was the way the arts commission intended to help individual careers. So, like Inspector Maigret, the great detective of French literature, I tried to get into the skin of each applicant. If I were them what would the fellowship mean?

I divided the fifteen applications into three piles of five: hot, not-so-hot, and no-go. I looked over the no-go pile and the not-so-hots, did a little rearranging, and put the no-go pile away.

The ten remaining applications included potters, jewelers, a photographer, a printmaker, and a painter. A good cross-section even though I hadn't planned it.

I laid the ten applications aside for several days, did my work, went on a weekend holiday to a small island, and generally put the whole fellowship process out of my mind.

When I picked up the applications several days later I put all of the slide sheets up on my big light box and had a little gallery show for myself. The slides of these ten applicants were all of good to excellent quality and about half were professionally produced — that is they were labeled "Photo by . . ." — and the name was not that of the applicant. So I assumed that these were done by professional photographers.

Incidentally, of the original fifty applicants about a third had "professional" photographs, but unfortunately they were not always up to what I would expect as a minimum professional standard. The professional quality seemed to vary almost as much as the slides done by the artists themselves.

Finally, I swallowed hard and selected four slide sheets. I then compared each with the other six non-selected sheets, made one change and felt greatly relieved. The four I had chosen were, as far as I could tell, the very best of all the applicants.

Happily, one of my choices was a potter whose work in porcelain was presented in a series of luminous transparencies which were by far the best slides in the whole group. I was

impressed both by the quality of her work and the excellence of her slides, which showed every nuance of form and opalescent color. She won on all counts.

Being a juror was an interesting experience and will certainly help the next time I have to shoot portfolio slides for a craftsperson. And it reaffirmed my conviction that while good photography won't get bad work into juried shows and exhibitions, bad photography of even superb work can definitely be a hindrance, and can even keep you out.

THE BASIC EQUIPMENT

The following is a list of the equipment you'll be needing if you expect, as most craftspeople do, to do much of your photography indoors. I don't know anyone who can get the sun and clouds to stay still for the days and evenings when there's a need, sometimes sudden and urgent, for craftwork to be photographed. So here's the basic list, though you might want to add an optional item or two later on.

- A 35mm single-lens reflex camera
- A 50mm lens, which will probably come with the camera
- Electronic strobes or flashes
- A light (or exposure) meter
- 35mm film
- Two lights of the same power and color with reflectors, clamps, and stands
- A tripod
- A cable release
- Simple background material such as paper or "black velvet"

I hate to make lists because they can look long, technical, and formidable. So, having made this one, I should point out that I'm here to show you that using this equipment is no more complicated than the craftwork you do and, I hope, will be as rewarding.

Bear in mind too that you won't have to negotiate a loan to buy this equipment. Excellent cameras can be purchased second-hand; film comes in bulk; and a major part of my job is to show you the best deals. Some of this equipment is inexpensive even without a deal. And for all of it, of course, you can get tax deductions and depreciation, since you're a self-employed business person. In addition, the equipment will pay for itself quickly because the cost of having commercial photography done could cost a few hundred dollars *each* time you have pictures taken. So the cost of doing your own work actually is reasonable and cost-effective.

Try it. You'll like it.

2

The Essentials of a Camera, New or Used

A CAMERA is almost a necessity for a craftsperson. If you're planning to buy one, new or used, read on; and if you have a camera that you're pleased with, read on, too, because you can learn about the special qualities of your camera and how to make the best use of it.

THE 35mm CAMERA

To produce slides for juried competition you *must* have a 35mm camera. Neither Polaroid-type instant cameras nor pocket disc cameras will do. Most of the pictures taken by professionals, and the majority of amateur photos, are taken on 35mm cameras.

A 35mm camera does not limit you because you can also get a wide variety of black-and-white and color-print films for it, and most such cameras will not only produce usable, quality pictures for juried shows, but will also provide what you need for personal record keeping, advertising, and family use.

All 35mm cameras share several basic controls. These are film loading and advancing; exposure-meter setting; focus, aperture, and shutter-speed settings; and, on the more expensive cameras, lens interchangeability. There are cameras on which *you* operate each control and many new ones featuring automation of one or more of the controls. With a little practice, anyone can learn to operate a totally manual machine,

and for craft photography the more control you have the better. Some automation is tolerable: I'll explain that later.

When you are looking for a camera for craft photography, buy a 35mm *single lens reflex* camera. Don't even look at compact 35mm cameras that fold up into your pocket or super-expensive rangefinder models. The single lens reflex (SLR) shows you the view *through* the camera lens. For craft photography it is *critical* that you see what the lens is seeing. A rangefinder or compact 35mm camera will have a small viewing window attached to the camera body *above* the lens and will therefore show you a slightly different scene from what the lens is seeing. This difference in what is seen is known as

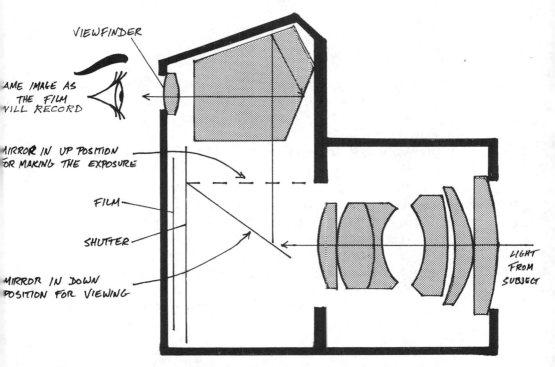

Viewfinder on a single-lens reflex camera. What you see through the viewfinder is exactly what the picture will be. A movable mirror reflects what the camera sees, and a pentaprism in the viewfinder directs that reflection to your eye. When you take the picture, the mirror moves up out of the path of the light so it can strike the film.

parallax, and the closer you get to what you're shooting, the more important this difference becomes. This explains why the tops of people's heads are sometimes cut off in close-ups, and why the top of your wood carving could also be cut off. So look at SLRs only.

As I mentioned, the basic 35mm camera (which gets its name from the size of film it uses) will have a control to advance the film, set the shutter speed, set the lens aperture, and do the focusing. That's *all* there is on a camera to set or adjust. Yet these controls and their uses seem to present problems to many people. People who drive cars, type, play musical instruments, or create beautiful handcrafted objects seem to fall apart while handling a camera.

Let's look at these controls carefully and then take charge of them.

FILM ADVANCE

Before you can advance a film, of course, you have to load it. Loading methods vary, and since the instructions that come with your camera will explain loading, I'll let the manufacturer handle that.

Film advance (or transport) is the easiest control to operate. Most cameras have a film-advance lever and you advance the film after each exposure. Many of the new automated cameras have a motorized film advance built into the camera body. After each exposure a tiny motor advances the film to the next frame, and on many it rewinds the film after the last exposure. Generally, if your main interest is photographing your work, you do not need automated film advance. Personally, I don't believe it's wise to have the film advanced automatically because it increases the chances of accidentally tripping the shutter when you put the camera down or pick it up.

SHUTTER SPEED

The camera shutter controls how long the film is exposed to light; the shutter *speed* contributes to sharp imagery by

reducing blur caused by camera motion. Most shutters are constructed of either diaphragm blades (usually on less expensive cameras, mounted between lens elements) or two moving curtains (mounted in the camera body).

On most modern cameras there is a dial on the camera's top deck that sets the amount of time the camera's shutter curtains remain open to expose film to light.

Numbers and Letters

The shutter-speed dial is marked in a standard series of numbers and letters. They are 1, 2, 4, 8, 15, 30, 60, 125, 250, 500, 1000, and the letters *B, T, A,* and *P* (although the *T, A,* and *P* are not on every dial). The numbers represent fractions of a second. For example, 4 means 1/4 second and 125 means 1/125 second. The larger the number the *shorter* the exposure time.

The *B* stands for "bulb," which means that as long as the shutter-release button is depressed the shutter will remain open. This allows for exposures of more than one full second.

The *T* setting is usually found on older cameras and stands for "time." At this setting the shutter remains open until the shutter release is pressed a second time. It's like the *B* setting for long exposures, but a bit more convenient.

If you own a modern automatic camera such as a Canon AE-1 or Nikon FE there is an *A* setting on the dial which engages the camera's auto-exposure system. At this setting the camera's light meter not only determines the light level but sets the shutter speed or the lens opening. In some cameras the system may be aperture-preferred — that is, once the photographer selects an aperture, the camera measures the light and sets the correct shutter speed for proper exposure. The alternative system is shutter-preferred; as might be expected, once the shutter speed is chosen the camera sets the lens-aperture setting.

P means "program"; this setting is simply a factory-set combination of speeds and apertures. On *P* the camera sets both the shutter speed and aperture. Although these auto

settings are handy they can be a problem in craft photography, as explained in the next chapter.

Electronic Flash Setting

There is another setting on a shutter-speed dial that is particularly useful with electronic flashes. This is the "synch speed" setting (from synchronization of shutter and flash) and is marked either with a small lightning bolt (because flashes are like lightning, right?), an *X*, or by one speed, usually 1/60 or 1/25, marked in red or yellow. The synch speed is the fastest shutter speed that you can set your camera to when using a flash. At higher speeds you'll only get a partially exposed frame. At lower speeds you can shoot but you begin to risk camera blur from the existing light level. It's best to set the camera to the synch-speed setting whenever you are using flash.

THE LENS APERTURE

While the shutter speed controls sharpness by reducing camera-motion blur, the lens aperture — the opening — affects sharpness by controlling the amount of light that reaches the film.

The lens aperture ring has various settings on it known as F-stops. Most modern, "normal" come-with-the-camera lenses have maximum aperture settings of F/2 or F/1.8. At that setting, the lens is wide open and a lot of light is allowed to reach the film. Such a setting can be used with relatively low light. Reducing the size of the lens opening is known as *stopping down*.

If you take the lens off the camera body and look through it, you will see an iris-type device whose opening gets smaller as you move the lens aperture ring from F/2 to F/2.8, to F/4 to F/5.6, etc. This iris, or diaphragm control, does two things. It controls the *amount* of light falling on the film (so you can take pictures in both bright sunlight and dim lamplight) and it also controls the depth of field. Depth of field, which is the sharpness of the objects in front of and behind the subject of the picture, will be discussed in the next chapter.

THE FOCUSING CONTROL

On most cameras, encircling the lens, there is a broad rubberized ring that is the focusing control. Looking through the viewfinder as you rotate this ring you'll see the image move in and out of focus. In the center of the viewfinder is a focusing aid that, depending upon the make of camera, will be either a split-circle rangefinder or a bumpy-looking microprism. (In some cameras it's a combination of the two.) While you can focus an image by just rotating the focusing ring until the whole image appears sharp, the central focusing aid gives critically fine focus, snapping the image into sharpness.

WHAT TO LOOK FOR IN USED CAMERAS

Because of recent changes in camera design, many older but mechanically and optically excellent cameras have turned up as trade-ins on dealers' shelves, victims of the trend toward lightweight, automated, motorized cameras, and they are some of the best buys around.

If you're in the market for a used camera, here are four things you should do:

- Carefully examine the camera for dents and signs of wear;
- Pay attention to the mechanics, checking out the shutter mechanism, listening to the gears, and watching the shutter curtains;
- And, if you buy the camera, run some film through it immediately to see that it works correctly;
- Ask about the store's warranty and return policy.

Now for the specifics of dollars and cents, and which cameras to buy. A good used camera should cost between 40 to 60 percent of its original price, depending upon its age and condition.

For example, a Nikon FM2 currently lists at about $479 for just the camera body — not including lenses. Many of the large east coast discount camera stores will sell it new for $400 (or slightly less on special package deals). A good clean used

Nikon FM2 should therefore sell for around $300, and anything from $250 to $280 would be a great buy.

The current model of the Nikon FM2 is at the high end of the used-camera bargains. But its predecessor, the Nikkormat, is a super buy. This camera accepts all of the new Nikon lenses and is very durable. The early Nikkormat FTn or FT should be available for perhaps $100 to $125. With their through-the-lens metering systems and sturdy metal Copal shutters, they are the used cameras to look for.

But beware of other models like the Nikkormat EL or the Nikon F. The EL is an early automated camera that seems to cause a good deal of grief for some of its owners, and many were traded in or just dumped.

The Nikon F, on the other hand, is a superb, rugged camera which is very much prized by working photographers. And that can be a problem. If you are not really sure of cameras and what to look for, you could get a Nikon F which has been rather thoroughly abused by a professional photographer. Generally, if a pro is trading in a Nikon F, it can be assumed that he or she has begun to question its reliability. For you, a Nikon F can be a great buy or a great mistake.

There are several other late-model single-reflex cameras of recent vintage that come to mind. The Minolta SRT 101 and the Canon FTn are two cameras you might look for. Also the Pentax Spotmatic (although its stop-down metering system can be a bit awkward to use) and some of the Pentax K series.

Avoid strange brands or very old equipment. My advice is: Stay away from cameras like the Nikkormat FS, that Edsel-like device called Nikkorex, the meterless Pentax H series, the Miranda F, the Petris and Towers, the lovely but bizarre Exactas, and almost every Kodak reflex ever made. It's not that any of these cameras are particularly bad, or that you couldn't find a decent one, but these are cameras you buy out of sheer love and a certain degree of masochism.

Cameras, like cars, are changed every few years, so you need to be cautious. Cameras over five years old may work well, but you may not be able to get new lenses to fit their obsolete lens mounts. And some cameras may represent design experiments that didn't work.

When you go out to buy a used camera, talk the salesman's ear off. Ask questions. Keep in mind that the store probably paid half of the asking price for the used camera, and that means the margin on used cameras is way above that of new equipment. The salesperson should be willing to talk about the bad points of a particular camera as well as its attributes. Remember that the camera store will make more money from you over the years when you buy its film, processing, accessories, and service than if you buy just a camera, so it is in the store's interest to make you a satisfied customer.

Used cameras can be a smart buy if you take your time, ask questions, and shop wisely.

3

Focusing: Depth of Field and Lenses

FOUR factors are essential for sharp photographs: fine-grain color film like Kodachrome 25 and 64, a tripod, a cable release, and sufficient depth of field.

The first three can be purchased, but the fourth has to be figured out. *Depth of field* is the sharpness surrounding the point focused upon — in other words, it involves keeping an entire object in focus. If your craftwork consists of ten-foot-long soft sculptures of, say, automobiles that you will be photographing from a distance of fifty feet, depth of field is not your concern; depth of field is important only for objects that are shot close up. The closer you get, the more you have to pay attention to depth of field. If your object is one-dimensional, like embroidery, there's no problem, either. But if you have a carved wooden tugboat and you want to shoot it coming toward you from two feet away and keep all of it in focus, stay with me.

If you're shooting a craft piece and find that the exposure is F/2 at 1/125 second, you know that if you set the lens to F/11 at 1/4 second you have an equivalent exposure because F/11 is five aperture numbers (stops) from F/2, and 1/4 is five settings from 1/125. Since you reduce the amount of light coming into the camera as you stop down, the exposure time must get longer.

The numbers on the shutter-speed dial are all in a 1:2 ratio; each number is one-half or twice the adjacent number. Even though it may not seem like it, 1/15 is twice as fast as 1/8 and

half the speed of the next setting: 1/30. Because both lens aperture and shutter speed are set in this 1:2 proportion, exposure adjustment is relatively simple.

Think of it as filling a basket with fruit; if you put in more apples you'll put in less oranges. Likewise, if you put in lots of light you'll add less time.

As you stop down — make the opening smaller, going from F/2 to F/8, for example — you *reduce* the amount of light reaching the film, but you increase the depth of the field — that is, the sharpness of everything in front of and behind the point you are focused on. If you were to focus on the front edge of a handcrafted box at F/2, the resulting picture would show the front perfectly, but the sides would be soft, fuzzy, and out of focus, as would anything in front of the box. Stop the lens down to F/11 or F/16 and the picture will now show the whole box as sharp and clear.

All this makes sense when you realize that at F/2 the diaphragm is wide open and lots of light enters the lens. In fact, too much light. Light coming in at angles to the exact center of the lens blurs the light coming straight down the middle (or axis) of the lens. These central rays produce sharp images, and reducing the size of the lens opening prevents the extraneous, blurring light rays from reaching the film.

The effect of cutting off these rays sharpens the image around the actual point of focus. When you focus on an object five feet from the camera, at F/2 the depth of field for a "normal" lens is from 4' 10" to 5' 2", just *four* inches! In this situation, a pot six inches in diameter is going to be mostly out of focus. Worse yet, focus on the front of the pot at a point five feet from the camera, and the depth of field only extends two inches beyond the front edge. But at F/11 the depth of field is going to be 4' 2" to 6' 2", or two feet, and that means that the whole piece is going to be sharp.

This relationship holds at most combinations of shutter and aperture setting, but it does fall apart at very long exposures. This situation (known as *reciprocity failure*) varies with each type of film, so be sure to read the data supplied with every roll of film to find out when the film goes into this failure process.

The basic rule for craft photography is to *stop down as far as you can to get the best depth of field.*

In a few cases, the camera does not allow accurate enough control of the lens opening to make good depth of field possible. Cameras with shutter-preferred systems or program systems (described on page 13), since they do not have manual lens control, are not useful for photographing small objects close up.

CAMERA SCALE THAT TELLS YOU THE DEPTH OF FIELD

Although most nonprofessional photographers are unaware of it, almost every 35mm camera that can be focused manually has a scale engraved on the lens barrel that tells what the depth of field is. When this scale is used in combination with the aperture markings depth of field can be read directly from your lens, and if you look at your camera lens you'll be able to see the relationship between focus and aperture. To find the depth of field you simply set the lens to an aperture, say F/8, and focus at, say, five feet. Next to the distance you are focused on you'll see colored lines or numbers on either side of the distance line that are related to the aperture setting. For instance, my normal lens reads a depth of field of 4′4″ to 5′9″ when the aperture is F/8 and the lens is focused at five feet. That means the depth of field is 17 inches in this example. At F/16 the field reads 3′10″ to 7′, or a bit more than three feet. Some of these figures may be approximate, but they're certainly close enough for the purposes we're discussing here.

WHEN FOCUSING, GO FOR THE FRONT

Because depth of field is always greater behind the point of focus, it is best, if you're photographing small objects, to focus on a front surface rather than a middle one. Be especially careful with small three-dimensional objects such as jewelry, miniature sculpture, and the like. Since viewfinders in cameras are very coarse ground glass, the image appears sharper when you're looking through the viewfinder than it will in the

photograph. Thus there is sometimes a tendency to focus three-dimensional work a bit back from front surfaces because that looks okay through the viewfinder. And then when the slides or prints come back, there's a large fuzzy edge right in the middle of the pictures. So focus on front edges and then go for the most depth of field by setting the lens to its smallest aperture (highest F-stop) and using a longer exposure time.

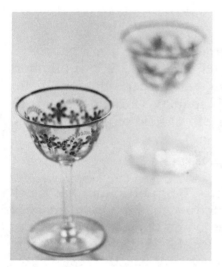 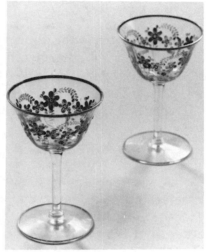

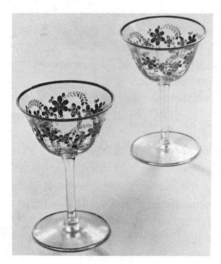

Depth of field. These two glasses were only four inches apart. The upper left picture was shot with the lens aperture wide open, at F/2, allowing the most light. The picture at right was shot at F/8; the one below at F/22. (A 90mm lens, with its narrower depth of field, was used here to dramatize the results; a normal 50mm lens set at F/4 would get a picture more like the one at upper right.)

There are limits to depth of field. If you have to photograph jewelry or other small objects, you'll find that even at F/22 there will be only an inch or so of depth of field. By focusing on the front edges you may find that some of the more distant parts of an object are out of focus. However, this need not be a concern because some background blur is acceptable. Foreground blur is far more distracting.

FOCAL LENGTH

Focal length is the approximate distance from the lens to the film, and it's described in millimeters as a lens number; a 50mm lens is the "normal" lens that you get with most 35mm cameras. A 50mm focal length is about two inches. Lenses with different focal lengths affect depth of field in different ways.

EFFECTS OF DIFFERENT LENSES

A wide-angle lens such as a 28mm or 35mm has much greater depth of field at any aperture than a 50mm lens. For example, a 28mm lens focused on an object at five feet has a depth of field at F/11 not of two feet but of nearly fifteen. On the other hand, telephotos and lenses with focal lengths of 100mm, 135mm or more, have very, very narrow depths of field. At F/11 a 135mm lens has a depth of field at five feet of only three inches. And that's at F/11, not F/2.

Why use a lens with such a skinny depth of field even when stopped down? The answer is perspective.

A 50mm lens is called a normal lens because it produces a photograph in which the perspective relationship among objects is just the way we normally see them. Wide angles, however, make near objects seem larger than distant ones and produce the familiar bug-eye distortion we've all seen. Because of their great area of coverage, wide angles are the best way to photograph interiors and are used by architects and interior designers, despite some distortion.

Telephoto lenses compact space. Distant objects are made large in comparison to near ones. A moderate telephoto

(90mm, 105mm, 135mm) produces a slightly flattening effect which makes objects appear, oddly enough, more naturally shaped. For many crafts — for example, a wooden form, a doll, a ceramic vase, or any piece that's sculptural — a moderate telephoto lens is the best type to use.

4

Buying Film:
The Best Kind, the Best Buy

THE most thorough knowledge of your camera won't be of much value without a good understanding of the film that goes into it, so let's move on to color film — which is probably what you'll be buying most — and then black-and-white, with a wrap-up regarding bulk buying.

COLOR FILM

Over the last few years, dozens of new color films have been introduced to the market. Super-high-speed films just about promise that you can shoot a black cat in a black closet without a flash. And although the world champion best color film ever — Kodachrome — marked its fiftieth birthday in 1985, even it has undergone a bit of refinement. Faster, finer-grain films are promised in just a few years. Besides the films I'm going to recommend (based strictly on personal feelings), you might want to try some new film every once in a while to see how well it works for your special needs. See the color film chart in the back of the book for a listing of color films and their specific characteristics.

But let's start with some basics.

Color film tells you what it is right in its name. For example, look at the names of these color films:

Kodachrome 64	Fujicolor 100
Ektachrome 160 T	Agfacolor 1000

The first part of the film name indicates the manufacturer. Koda- and Ekta- are films from Eastman Kodak. Fuji means it's manufactured by the Fuji Company of Japan, and Agfa by the Agfa Company of Germany. The next part of the name tells you whether the film is for slides (chrome) or color prints (color). The numbers refer to the film speed. The larger the number, the more sensitive the film is to light and the less light you need for picture taking. Thus, Agfacolor 1000 is a high-speed (very light-sensitive) color-print film from Agfa.

Films are generally classed by their speed. Those with numbers of less than 100 are considered "slow" films. Those with numbers of 100 to 200 are medium-speed film, while those numbered over 400 are high-speed film.

(These numbers are from the ASA and ISO systems — the American Standards Association and the International Standards Organization. The larger the number, the more sensitive the film; if the number is 200, the film is twice as sensitive as one marked 100. A small dial on the camera allows you to set the camera meter for the ASA/ISO number of your film for correct exposure.)

As film speed increases, so does the speckling, or *grain*, of the picture. The graininess of a film directly affects how large a print you can make or how large a slide can be projected before the speckling becomes really objectionable.

With this increased grain comes loss of detail and loss of strong contrast.

So while the new high-speed films are a boon to available-light photographers such as photojournalists, they are too grainy for the average craft photographer or commercial photographer.

Slide Film

When shooting slides for juried shows, competitions, or publication, I would use either Kodachrome 25 or Kodachrome 64. Kodachrome 64 is a little faster than Kodachrome 25, but still produces the same rich, grainfree image. Kodachrome needs to be processed by Kodak, which takes time, so if rapid

processing is needed — say you need slides the next day — then use either Ektachrome 100 or Fujichrome 100. Both of these can be processed overnight by the local processing labs now found in almost every major community.

I choose Kodachrome for craft slides because I feel it is simply the best for this type of work. But there are a few points to make about a film even as wonderful as Kodachrome.

The first thing to remember is that all color film produces only an *approximation* of the colors of the real world.

Made of multiple layers of dyes and image-sensitive silver chemicals, color film is very delicate material. The layers that are light-sensitive divide all the colors of the world into, incredibly, only three colors, One layer records the magenta (red); another, the cyan (blue); and the third, the yellow components of light. It is the overlapping of these three that produces all the colors in a photograph. I find it pretty amazing that mixing just three colors can produce thousands of different colors. But each film has its own recording limits and its own built-in color bias. Kodachrome colors are a bit on the warm side, while Fujichrome seems a bit more green and cool. Agfachrome produces great gold and brown tones but its greens are kind of wishy-washy. For craft slides, I feel that Kodachrome has the edge both in color fidelity and grain, but its color may not be *exactly* the color of an object.

Basically, though, modern color film does a great job and I'm just pointing out that you may have to accept some slight variation from the colors in your work.

Color-Print Film

If you need to produce color prints, use a color-print film like Fujicolor 100 or Kodacolor 100. Both are excellent and will produce rich, grainfree images that can make prints 11" x 14" and even larger.

Since both slides and negatives can be used to make prints, you might wonder why I suggest using color-print film at all when a color print can be made directly from a slide.

The answer is that the negative made from color-print film is less contrasty than slide film. Put another way: slide films

and the paper used to make prints from slides are very con-
trasty. A slide that is brilliant and contrasty (snappy!) when
projected on a screen may print terribly, with the bright
highlights washed out or black areas turned to muddy gray.
This is often the case with prints of sunsets, for example.

Color-print film can handle this contrast range. Since the
paper used to make color prints is also less contrasty, it helps
hold the highlights and blacks, especially when objects are
shiny or highly reflective.

Daylight-Balanced Film

Most color film, whether for slides or color prints, is
"balanced" for use with daylight. This means that it should be
used with daylight or, lacking that, with *blue* floodlights or with
electronic flashes. If daylight-balanced film is used with
household lamps, clear tungsten floodlights, or quartz lights,
the results will be orangy-red and unsatisfactory; for these lights
use a film such as Kodachrome 40T (T for tungsten) or a color
conversion filter such as described in Chapter 6.

Beating the Age Problem

One reason slide film tends to have slight color variations
is that the color layers are affected by age, a fact that film
manufacturers take into consideration. Allowing film to age
is part of the production process; like wine, ready-to-use film
must mature for a while before it leaves the manufacturer.
Kodak and other film companies decide when to release film
to stores by testing a few rolls from a production run every once
in a while.

Most of Kodak's color products are made for an amateur
market with the expectation that people will put a roll of film
in their cameras at Christmas, shoot a few pictures, and then
put the camera away until Easter. The expectation (based, I
assume, upon research) is that a roll of film may be left in a
camera for a year. Add that to the time the film has already
spent on a dealer's shelf and you are talking about a long period

of time before the film is processed. So the manufacturers send film to dealers a bit before its "time," trying to allow for the aging that will occur on the shelf.

"Young" film will tend to have a magenta color while "old" film goes green, neither of which helps your slides. You want film that's at its absolute, color-accurate peak. And that's the point of Kodak's professional films. These films are carefully tested and released just at their peak. To insure that they stay that way, they must be refrigerated (preferably in a freezer) both in the store and at home until a few hours before use and then processed as soon after exposure as possible.

While refrigeration can be an inconvenience — after all, it's a bit embarrassing when your guests open the freezer and boxes of film fall out and there's no ice — the results are well worth the bother. Kodak's Kodachrome 25 in professional film is the same great color film as the "amateur" version, but now it's available at its best. Kodachrome 64 and most of the Ektachrome films are available in the new professional line too, so if you use Kodachrome this is the way to buy it.

BLACK-AND-WHITE FILM

Paradoxically, black-and-white photography is both simpler and more complex than color work. It is technically less complex than color, being both easier to process and generally more forgiving of exposure errors. But because black-and-white photos are an abstraction of the real world — after all, they lack color — they can be difficult to do well.

There are three kinds of black-and-white films: those with ASA ratings of 32 to 50, which are extremely fine-grain and very sharp; those rated ASA 100, which are slightly less sharp and not quite so fine-grained; and films rated ASA 400 to 500, which are very sensitive to light and have moderately fine grain. (See page 25 for an explanation of the ASA system.)

In selecting film for your black-and-white photography, two factors should be considered. One is the size of the final prints, and the other is the amount of lighting available.

The tiny grey specks that we refer to as film grain are not of concern for prints of 5 " x 7 " or less in size. But if you need

a print 8" x 10" or larger, grain is something to watch. For 8" x 10" and larger prints, you should use a medium-speed film (ASA 100) such as Kodak's T-MAX 100 or Ilford's FP-4.

The slow films (low ASA numbers) are great for big enlargements because the grain is so fine and will be less evident when it is blown up, but unless you are using studio lights, the slow films may be a problem. One of the reasons to use medium-speed or fast film is to be able to stop down your lens to a small aperture, say F/11 or F/16, in order to get the greatest depth of field in your photos. Out-of-focus areas in color photos are much more acceptable than in black-and-white prints, so you need extra depth of field in black and white.

If you are using only normal indoor lighting for photographing your work, a fast film like Kodak's Tri-X or Ilford's HP-5 will work. Although fast films are relatively grainy, they are still very usable. But don't send black-and-white film to the local drug-store processor. While there's a lot of money in color processing and even the smallest lab will do a decent job, that's not so with black and white. Because of the comparatively small volume of black-and-white processing, many labs relegate it to the back of the shop. Careful processing will keep the grainy characteristics of even a fast film to a minimum, but sloppy processing will produce increased graininess and higher contrast. Look in the Yellow Pages for a good lab specializing in black and white, and talk to someone there about what you need to do to get maximum-quality prints from their lab.

BUYING FILM IN BULK

Sooner or later the day will come when you have a 20-exposure roll of film in your camera and you'll need to shoot only a few frames. Furthermore, you'll be in a rush to get your pictures out, so you'll shoot about eight frames and take the film out of the camera for processing — wasting more than half the roll.

There is a way to deal with this problem and to effectively reduce the cost of film about 40 to 50 percent. Most film, both black-and-white and color, is available in 35mm cartridges of

20 and 36 exposures, or in long rolls of 27½, 50, or 100 feet. Buying film in these long lengths will save you nearly half the cost of buying individual rolls or cartridges over the counter.

For example, a 100-foot roll of T-MAX film costs about $40 and is equal to twenty rolls of 36 exposures each. Those twenty rolls would cost about $4.50 each in a store, a total of $90. Since you can load film cartridges with any number of exposures — 10, 15, 20, 24, 36, 40 — you can load a few short rolls and keep them on hand for photographing just two or three pieces at a time.

To load your own film cartridges is very simple. At any well-stocked camera store you should be able to buy a bulk film loader. A few types are available, and they generally cost about $20. Reloadable film cartridges cost about 30 cents each. You will need anywhere from ten to twenty of those.

Bulk film that comes in 27½-foot lengths has precut film leaders for five 36-exposure rolls. Don't buy this film unless you *want* 36-exposure rolls. With 50- or 100-foot lengths you can load any number of exposures up to about forty-five into a cartridge.

Both Kodak and Ilford provide their black-and-white films in long bulk rolls, but color film is another matter, since Kodachrome slide film is not available in bulk. Fortunately, several of the Ektachromes do come in bulk loads, and there are a few types, such as slide-duplicating films (not available in cartridges), that can also be purchased for slide photography.

After the initial investment in the loader and the cartridges, you will begin to realize a substantial saving on film. Be warned, though, that many color processors will charge you the normal 26- or 36-exposure price no matter how few or how many exposures you've loaded. Some processors won't return your reloadable cartridges, either.

The best thing to do to solve this problem is to take your slide film to a custom lab and explain what you want, or to a friendly lab that wants your business, or process the film yourself. There are several processing kits on the market with which you can develop your slide film. Although the processing is fairly straightforward, it will require some patience on your part to get the hang of it.

Bulk loading can be especially worthwhile if you shoot a lot of film or if you are always in need of an unusual number of exposures on a roll. Once you get the knack, bulk loading film will save you money and give you an edge in the battle of control of your overhead. Just plan to invest some time in becoming skilled at it.

5

Shedding the Right Light
on the Subject

Now we're at the heart of photography: light. When one looks at lovely mid-nineteenth-century family portraits or touching photographs of Civil War soldiers, it's clear that sophisticated equipment is not the key to memorable pictures. Light is. The secret of success is to watch the light more than the subject.

However, there's nothing wrong with getting some help. Two familiar and essential helps in this technological age are the light meter and the electronic flash.

LIGHT METERS

A light meter measures the amount of light in a scene and gives the exposure setting to be used in making a photograph. Most cameras today have built-in light-meter devices that are connected either to the aperture or shutter control, or both. As you match the viewfinder's needle or lights, you not only find the correct exposure reading but you set the camera to it and are ready to take your picture. This built-in meter is usually quite sufficient for a craftsperson.

For professional photographers, there are advantages in using hand-held meters, which show readings that then must be set on the camera. First of all, with a hand-held meter you can take readings of a scene and all its parts without having to move the camera. In studio work this can be very important. Second, most hand-held meters allow you to read the

incident light — the light falling on a scene before it bounces off the object being photographed. (Built-in camera meters read the light *reflected from* a scene.) Incident light readings are done with a small white dome over the meter cell. By pointing the meter at the camera from where the object is, the photographer gets a reading of the light falling on the subject. In a studio, with several different lights pointing every which way, this kind

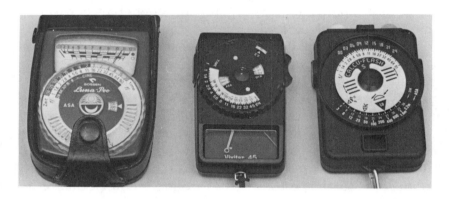

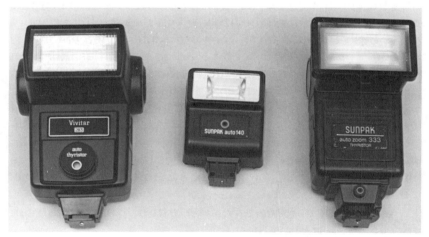

Hand-held light meters (top) and portable electronic flashes. The two light meters on the left are "continuous," for normal daylight and tungsten lights; the one at right is a flash meter, which reads the extremely short intense bursts of light from an electronic flash. Portable electronic flashes such as those shown below have all but replaced "one-shot" flash bulbs in most photography.

of meter can be very useful. Another type of hand-held meter is the flash meter, which can test and read the very short, very bright, bursts of an electronic flash — again very important for studio work.

ELECTRONIC FLASHES

Modern electronic flashes — which have all but replaced the old flash bulbs — allow photographers to carry a lot of light in a very small package. There are three types: manual, automatic, and dedicated.

Because the electronic flash has such a very short duration, it is difficult, without a special meter, to determine the correct exposure. To solve this problem a manual flash will usually have a scale printed on its surface that will tell you which aperture to set your camera at, according to distance from the subject. This gives you an aperture which may or may not be correct — shooting in a white-walled room, for example, will give a brighter picture than a picture taken in a dark-walled room at the same aperture. To get around this and other problems, the automatic flash was developed. This has an electronic sensor, usually built on the flash, which sees the light put out by the flash and cuts it off when a predetermined amount is reached. That amount is set by a switch on the flash that can be set to an aperture reading. After setting the flash to a chosen aperture you set the camera lens to the same setting and shoot.

The newest step in the technological development of flashes has been the dedicated flash. These units are camera-specific and connect to the internal electronics of the particular brand of camera. The system produces the correct exposure through the camera's light-metering system or through connection to an automatic program.

With a little practice, any of these three types of flash can produce good craft pictures.

OUTDOOR PHOTOGRAPHY
With Natural Light

Although craftwork is usually photographed in a studio because it provides consistency and the greatest control,

craftwork can also be photographed outdoors, and with great success.

I'll start where most of us started with photography: outdoors with natural light. My first suggestion is: Do not take your craftwork for a romp in the woods. I can certainly understand why many craftspeople feel strongly about the connection between their work and the natural materials they use, but I have yet to see a photo of a craft piece next to a tree, rock, or squirrel that really works. A wooden box photographed on a tree stump doesn't say "finely crafted wooden box made with great care and skill." It says "tree stump and box" or "from mighty oak to mighty nice box." Look at magazine ads that have scenic backgrounds and you'll realize that they usually use the setting to distract us from the product. This is not your purpose.

When the sun is out and you want to get some shots of your work, take outdoors a simple background material such as a roll of light-colored paper or plain fabric along with the work to be photographed. And take along a large, very white piece of posterboard. Set up the background and have a friend hold the posterboard while you operate the camera.

Bright sunlight is good for any craft that has a matte or relatively nonshiny finish: raku, textiles, basketry, batik, ironwork, and stitchery, to name just a few. Set up the working area so that the sun is to your left or right, over your shoulder. Focus your camera on the craft piece and have your friend move the posterboard so that it lights up the shadowed side of the piece. This will reduce the contrast in the final image. After you are happy with the reflected light, get your exposure, making sure that the posterboard is out of the frame, and shoot. It would be wise to shoot at a shutter speed of 1/125 second (if you don't use a tripod) to avoid camera shake and blur.

Here, as in most situations, you will want to *bracket your exposures*: shoot the image at the meter-recommended shutter speed/aperture setting and then, for insurance, at one or two stops more and less exposure. Because there are so many variations in photography, this is the only way you can be sure of getting the picture you want, no matter how high-tech you and your equipment may be.

With Flash

Another method of outdoor photography is to use a small electronic strobe to put some light into the shadowed areas of a craft piece lit by bright sunlight. The strobe allows a bit more accurate control of the shadow than the simple reflector and it is not hard to use.

After setting up your piece, take an exposure reading. With Kodachrome 25 you probably will have a reading of F/8 or F/11 at 1/60 second. You will need to get a reading at whatever shutter speed synchronizes with your camera flash. For most cameras this is either 1/60 or 1/125 second. If your aperture reading is F/8, set the strobe to F/4 if it is automatic or move it however many feet from the piece is required according to the flash's instructions to produce an F/4 exposure. You could try a frame with the flash at F/5.6 to compare the results with the F/4 frame. In any event, the flash assures that the contrast between direct sunlight and the shadowed side is no more than a ratio of 2:1 or 4:1 — well within the range of the film to produce texture in the highlights and detail in the shadows.

This "fill-in" flash method can also be put to work when you want to photograph your work at your booth at an outdoor craft fair. Even if you just use the flash mounted on the camera's "hot shoe" you'll find that by lightening up the deep shadows you'll improve your photos. (The hot shoe is the shoe, or bracket, on the camera to which a flash or meter or other accessory can be attached.)

One caution, though, when using fill-in flash. The light from the flash diminishes rapidly with distance. This means that if you're taking pictures at a fair and are close to your booth, say less than six feet, the pieces near you may be fine, but the pieces further away will not show any lightening of the shadowed areas. Because the camera is set to the daylight exposure reading, and the flash at one or two stops less, there is little chance of overexposing the picture, but you won't have the farther-back shadows brightened.

(Incidentally, if you stroll through a craft fair photographing other craftspeople's work, you might consider asking permission before you shoot. Copyright laws and courtesy make it

the wise thing to do. When you talk to people about their work, you then are sharing, not stealing, ideas. It's an area many people are sensitive about and it needs to be dealt with as tactfully as possible when you're behind a camera.)

Shiny Objects

If your outdoor photography involves shooting an object with a glaze or other shiny surface, you won't want to go out in the sun. But you *can* use the shade or just wait for an overcast day. Photographing in the shade can be a problem in some cases. The light in the shade is not direct white sunlight but light reflected off the blue part of the sky. Some color films are sensitive to this shade of blue and the resulting photos will be too bluish. Overcast days are a bit less blue and may be preferable to open shade. In either case, you won't need a white reflector, but you will need to keep an eye on the reflections in the shiny surfaces. A silver bowl reflecting your back yard is not going to make a good photo.

Within these bounds you should be able to produce good photos of your shiny work and spend some pleasant afternoons outdoors.

INDOORS: ARTIFICIAL LIGHT

Many photographers enjoy using natural light when making photographs. Natural light has great range and is very evocative. Unfortunately, it isn't consistent enough to be dependable when you're photographing crafts.

If you are serious about photographing your work, you'll want to consider the purchase of lighting equipment. With the right lights you'll be able to produce consistently sharp, color-saturated photographs. There are several types of lights you can use and they can cost anywhere from $15 to several hundred dollars each. Inevitably, the better the lights, the more expensive. Whatever you buy, you'll have to get reflectors, clamps, and the stands to go with them.

If you buy floodlights you'll need to be aware of their strength. Although floodlights screw into ordinary sockets they

produce a lot more heat and draw a lot more energy than ordinary bulbs. Two floods on any one outlet or electric line is all you want to use. Remember, watts equal volts times amps. Two 500-watt lamps will draw nearly two-thirds of the load limit on a 15-amp circuit. Three or four can exceed that limit. Often you can focus and position your pieces by room light before you have to turn on the floodlights.

Remember too that tungsten lights, floodlights, fluorescent lights, and skylights all produce different colors on film and should not be used together. Leaving a fluorescent lamp on somewhere in the studio can produce a strange green tint in the shadow areas.

Tungsten Lights

The simplest lights available are large 250- or 500-watt tungsten lamps (also known as indoor-type lights). They should be used with the heavy-duty reflectors made to go with them,

Detail of embroidery shot with light from tungsten lamps. In this case the lamps were placed at uneven distances from the subject, a technique that can be used to create textural emphasis on fiber arts such as weaving. (Artist: Elly Smith)

and are available as blue bulbs or clear lamps. You'll use the blue bulbs with daylight films, and the clear bulbs with tungsten films (marked with a T).

Tungsten bulbs do not last very long because they operate at such high temperatures, and after eight hours they usually will change color or burn out.

Quartz Lights and Electronic Strobes

Quartz lights are similar to the lamps used with TV and movie cameras. They produce warm light and should be used with tungsten-balanced film or daylight film with a filter. Although smaller than the tungsten bulbs, quartz lamps put out much more light and for ten times as long. But while you'll pay $26 for a tungsten lamp and heavy-duty reflector, you can pay that for a quartz lamp bulb alone. A quartz lamp with a reflector and socket will cost $50 to $100, depending upon the lamp size (600-watt or 1000-watt model) and the reflector you get.

The next step up is electronic strobes, which are what professionals generally use for craft photography. These are the most color-accurate and most intense lights available. As mentioned before, electronic flashes are for use with daylight-balanced film.

For most types of craft photography you'll need two similar lamps (floodlights, quartz, or flash) and two stands, so you can easily spend $200 or more for lighting. Is it worth it to buy quartz lights instead of tungsten or to spend even more money on electronic strobe lights?

It depends upon your expectations. If you subscribe to a craft magazine such as *Ceramics Monthly* or *Fiberarts* you'll see some good craft photography, and odds are that all of the pictures were made with either electronic strobes or large quartz lights. If those photographs are the kind you want, you're not likely to get them with tungsten floodlights. I often see craft photos that are warm in color (kind of brown where they should be black) or pictures with very small areas of sharpness. These are generally the results of using (or misusing) simple tungsten lamps.

I'm not going to tell you to go out and spend a lot of money on specialized equipment that's intended, basically, for people whose livelihood is photography. Tungsten lights, especially if you become familiar with them, can do the job. But you do have some alternatives.

A Good Buy: Sugra Photosystems

Sugra is a photographic-supply company in Pittsburgh (3045 W. Liberty Avenue, Pittsburgh, PA 15216-8051; tollfree phone 800-221-9695) that stocks many unusual and useful devices. Their AC Spiralite, a small electronic strobe, can be attached to a camera and is a bit more powerful than most camera-mounted units. At about $60.00 it can be a good buy for the craftsperson. Because the strobe is a plug-in AC unit, it won't work for party pictures, but it can be the basis of a low-priced studio system.

Sugra sells a complete lighting system and accessories for the Spiralite including stands, umbrellas, soft-box attachments and much more. In fact, there's a 20-piece system available for $399.95 which contains two strobes, light stands, umbrellas, clamps — a complete studio set-up. It also offers a flash meter, which is absolutely necessary for getting accurate exposures with electronic strobes.

Each flash in the Spiralite system has a guide number of 100 when with ASA 100 film. This means that with two strobes, Kodachrome 64 slide film, and the lights between five and six feet from a craft piece, you'll need to set the aperture at at least F/8 and shutter speed at 1/160 or 1/125, depending upon the type of flash setting your camera provides. This gives you a lot of rich light to work with to get good indoor photographs of your craftwork.

A QUICK GUIDE

TO CORRECT EXPOSURE

Whether you have a built-in or hand-held light meter, here are some tips for finding the correct exposure or a starting place for bracketing.

- Set the meter to the correct ASA/ISO number for the film you are using;

- Point the meter or camera at the object you're shooting — not at the lights or background;

- Set the camera shutter-speed dial to 1/30 or 1/15 second if you're using a tripod, 1/60 or faster if your camera's hand-held;

- Find the correct aperture by activating the meter according to however it's done for your camera, and moving the appropriate control;

- Be aware that if the light is very low you may have to lower the shutter speed to 1/8 or 1/4 second to get an aperture reading, which increases the possibility of reciprocity failure because of the slower speed;

- Take a picture at this reading and then bracket your exposure, taking at least one frame at one stop more exposure and one frame at one stop less.

6

Filters, Tripods, Cable Releases, and "Color Insurance"

FILTERS

ONE of the most important jobs of a photographic filter is to protect the camera lens. Once while covering a very crowded meeting I was jostled, and a $200 high-speed lens fell out of my bag and onto the hardwood floor. The $6.95 filter covering it took the impact and shattered, saving the lens from any damage.

Photographic filters serve other functions besides protecting the lens, of course. There are filters to correct color, produce special effects, and even change and distort the colors of the real world.

Photographic filters are discs of optical-quality glass which are mounted in threaded metal rings and screw into the front of your camera lens. Usually when you purchase a camera the salesperson will suggest that you buy a filter to protect your new lens. It's a good idea, but you have to be careful about the type of filter you buy.

Filters for Color Film

Filters are available in many colors and tints and can be used interchangeably on camera lenses. Most salespeople will encourage you to get a "skylight" filter, a pale pink filter that is supposed to warm up your color pictures. It does this in part

by reducing the amount of ultraviolet light reaching the lens and the film.

This ultraviolet light, which is invisible to our eyes but not to film, is the main reason that mountain and snow pictures are often much bluer than the way we remember things. The skylight filter, or 1A (all filters have a number or number-letter designation), counteracts that bluishness and warms up skin tones as well. But it's not the best choice for craft photography.

A clear UV (ultraviolet) filter will also reduce the blue, to some extent, and will protect your lens *without* adding any color tint. If your work has lots of grey, white, or silver, you must avoid a filter like a skylight, which adds a tint to these areas.

There are several other filters that are useful for craft photography, such as color-conversion filters. These match your color film to any one of several types of lights and are listed in the color-conversion filter chart at the back of the book.

For example, a blue 80A filter will let you shoot a daylight film, such as Kodachrome 64, with tungsten floodlights. Without the filter the colors would all be red-yellow.

An FL-D filter will correct the greenish glow of fluorescent lights and an 81A can warm up the color of an otherwise grey and overcast day.

There are even color-compensating (CC) filters, very pale colors such as reds, magentas, and yellows, that can be used to make very small color changes to fine-tune photos.

Kodak produces several publications that explain and illustrate the use of filters. Ask your photography store about them.

Filters for Black-and-White Photography and Special Effects

Filters are also very useful in black-and-white photography of craft objects. In this case, the filters are deeply colored and are used to change the grey tones in photos. Black-and-white film "sees" the world differently from the way our eyes do. Bright red and green look very different to us, yet they can easily appear the same grey in a black-and-white print. An apple with large green and red areas will appear to be one continuous tone. The same can happen if your craft piece has different color areas of equal tone.

In black and white you use a filter to lighten its own color and darken its complement. A yellow filter lightens yellow and darkens blue, a green one lightens green and darkens magenta, and so on. (See the section on techniques for black-and-white photography in Chapter 11 and the chart in the back of the book listing filters for various situations for black-and-white film.)

Filters can be used without causing any significant loss in image quality.

There are also several dozen special-effect filters which can soften pictures, create multiple images, and even change the color of things. Although they aren't as useful for crafts photography, they are great fun to experiment with, and sometimes the results are striking.

TRIPODS

He had just fallen behind cover, heat rays flashing all around him, when over a rise he saw the three-legged Martian war machines advance towards his position.

I was pretty scared when I read H.G. Wells' *War of the Worlds* at age ten. The image of three-legged war machines stayed with me into adulthood until one day, standing in a camera store, I realized the reason for three legs on the war machines — *stability*. Those Martians were not only smart enough to travel across several million miles of space, but they knew that a tripod is one of the most stable ways to support something. No wonder we almost lost Earth to the Martians.

I'd hate to have to count the times I've explained a particular method of photographing crafts by saying, almost as a throwaway, "Placing the camera on the tripod . . ."

You're probably going to want to consider buying a tripod because you'll need to use small lens openings to get sufficient depth of field so that all surfaces of your work are in focus. This means you'll need exposures of at least 1/15 second — much too long for hand-held shots — and this in turn requires stability: a tripod.

All tripods share the characteristic of three-leggedness; beyond that they are very different. There are small tripods that

stand no more than six inches tall and others that are well over six feet high. There are lightweight tripods and huge massive ones. Each is designed for a specific purpose and works best when used for that purpose. The larger tripods are generally used for large-format cameras (that use 8" x 10" or 5" x 7" film), or TV and movie equipment, while the smaller ones are meant for 35mm still photography.

When you're in the market for a tripod, it's best to go into a store and open every tripod (or have the salesman do it). If you are using a 35mm camera and a lens with a focal length of less than 105mm (see page 22) you need a sturdy but not necessarily heavy tripod. Tripods generally have telescoping legs so that they can shrink to a foot or two in length for storage but open up to provide firm eye-level support when needed. Since everyone's eye level is different, open and extend each tripod to see whether it feels comfortable at your eye level. Many tripods have an elevator column that lifts the whole camera platform twelve to eighteen inches above the leg joint. Look for a tripod that will lift a camera a bit above your eye level. Besides the extra extension being handy for odds and ends of uses, it allows you to use the tripod a little less than fully extended, which will keep it more rigid.

Tripods have either tubular legs with twist locks or U-shaped channel legs with snap locks. I prefer the tubular-leg models, but then I'm willing to carry around a pair of pliers to loosen an occasional jammed lock. Some tripods have tubular legs with small buttons which lock the leg sections in place when fully extended. The lack of intermediate settings makes this a less-than-perfect arrangement.

The tripod head should provide controls to move the camera as freely as possible. A good tripod will have a control which lets you rotate the camera a full 360 degrees. There should be a lever or other control that lets you point the camera up or down, and a separate control to tilt the camera to the left or right.

Tripods vary in cost, but you should expect to spend between $50 and $100 for a decent one. Just as a matter of interest, one European company, Gitzo, makes the Rolls-Royces

of tripods, precision devices that provide the most stable, solid shooting platforms possible.

A medium-size Gitzo 35mm tripod can cost several hundred dollars — not what you want, but well worth the money for certain professional photographers.

Table-Top Tripods and Minipods

If you are, as I suspect many crafts people are, producing work that is less than twelve inches in its major dimension, a normal-size tripod can present the problem of getting the camera close enough to your work to photograph it well. The long tripod legs are going to bump up against the table edges and get in the way. I hardly have to mention that most tripods are heavy, and even when collapsed don't fit into a camera bag.

There is an alternative choice, and it's portable and inexpensive — a table-top tripod or minipod. These are sturdy enough to give you a steady base for your camera and small enough to sit just a few inches away from your work.

The table-top tripods are just scaled-down traditional tripods. Several extend to a height of five feet, but they are pretty shaky at that extension. Compacted, they work very well. They scrunch up to under a foot in length and most weigh just a pound or two. The best part is the price. Most range in cost from $15 to $40.

Minipods are different in that they do not have telescoped legs. They simply open up and provide a short and very firm camera support. They also cost in the $15 to $40 range, with one elegant minipod made by the famous Leitz company of Leica camera fame costing a hefty $60.

An accessory well worth getting when you purchase a small tripod or minipod is a ball-and-socket head (not the same as the head that comes with the tripod). This little device screws in between the tripod and the camera. A single lever on the unit releases the ball in its socket so that minute changes in the angle and level of the camera can be made. Once the camera is in the right position, the lever is flipped down and the ball is locked in place. There are lots of ball-and-socket units around and they cost anywhere from $5 to $25.

If you get a small tripod or minipod for shooting your work in a table-top situation, you will be pleasantly surprised to learn that these tripods are equally useful out in the field. Whether indoors or outdoors, small tripods make excellent supports for shooting in low light.

Brace the tripod against your chest or shoulder (or a wall), release the ball head, and adjust the unit until you can easily see through the viewfinder and lock the ball head in place. You'll find that while hand-holding the camera you can make sharp pictures at exposures in the range of 1/4 to 1/15 second. When you're done, the whole thing slips easily into a camera bag or large purse.

Table-top tripods and minipods are a small investment that will give you a large return in sharp, clear photographs.

So now that you know all about tripods, I will be able once again to write, "Placing the camera on the tripod . . ."

THE CABLE RELEASE

While we're on the subject of keeping the camera stable, let's go on to the skinniest piece of equipment, the cable release. Cable releases are long thin tubes that allow the photographer to trip the camera shutter without having to touch the camera, which could result in shaking or jolting. Most cameras have a threaded socket on the shutter-release button where a cable release can be screwed in. Squeezing the cable release gently trips the shutter and makes the exposure.

ASSURING THE RIGHT COLORS AND GREYS: COLOR STRIPS AND GREY CARDS

Everything changes the color of the pictures you take: lighting, the type of film, the anti-reflection coatings on your lens — everything.

The color reproduced by film is an approximation of the actual color and range of intensity of light which your eyes see. To try to match the real-world colors to those in photographs we produce, we need some kind of constant in the picture-taking situation. You could perhaps toss a bright red sweater

into the next photo you take and, when you get the pictures back, compare the sweater to its image. Although this works, it doesn't tell you anything about the way blue or green or yellow or magenta are being recorded. If you want a very accurate print made from your slide or negative you would have to give the sweater to your local color printer. Obviously, using something as arbitrary as a sweater is somewhat effective but is very impractical.

Kodak and other manufacturers produce several simple and inexpensive tools that can provide you with excellent standards with which you can control the colors of the slides or color prints you get. Available for less than $10 each are Kodak's Neutral Grey Cards and Color Patch Strips. Or, instead, you can buy a copy of the *Kodak Professional Photoguide.* This handy book includes the grey cards and color patches as well as lots of very important data about using Kodak films. The *Photoguide* costs less than $20.

The Color Patch Strip is a standardized and carefully manufactured set of colors. Each color is printed from specially mixed inks and the colors themselves are standards set by a national standards group. Besides the color patches, there is also a strip of grey patches which again are strictly controlled to meet certain standards. The Neutral Grey Card has an 18 percent reflectance surface that is middle grey, the standard to which exposure meters are calibrated.

These standards are very easy to use. If you place the color strip in the very bottom of your frame when taking a picture, a color printer can match your color strip to his own and produce a very accurate reproduction of the original scene. Once a correctly balanced print is produced, the color patch is excised out of the picture with a papercutter. To use the Color Patch Strip with slide film, shoot one entire slide of the strip.

The grey scale (which can be used for all film, not just black and white), is also used to get information about exposure and processing. Again the scale is placed so that it appears at the very bottom of the picture. And again, if the film is correctly exposed and processed, all eight of the grey steps should be distinct and the correct tone of grey.

Most of the time, though, the grey card is used to find the correct exposure but is usually not photographed. If you want to photograph a white porcelain pot on a black background, for example, you'll find that it is very difficult. Your exposure meter, especially the kind built into the camera, will not produce an accurate reading. A meter which reads mostly the pot (a spot meter) will make the pot too grey and dingy, while an averaging-type metering system will make the black background turn grey and the pot so washed-out-white as to disappear.

So, if you have a grey card, you put it in the scene a few inches in front of the pot, halfway between the main light and the camera, and move the camera to about two feet from the card to take an exposure reading of the card. Tilt the card slightly upward toward the main light or the camera. That way you'll get accurate exposures regardless of the coloration or tone of the piece, the background, or the lighting. Although it is always wise to bracket your exposures, using a grey card will insure correct exposure in most situations.

The absurd simplicity of the grey card and standard color patches belie their importance to accurate and color-correct photography. Sometimes when I haul off and drop several hundred dollars for a large order of color film, I will shoot one roll using a grey card for exposure, including color patches in every shot. When I get these pictures back from the processing lab I will know whether I have to compensate for any color shift inherent in the film in manufacture.

There is usually some color shift in photographs and generally it can be ignored. But every photographer has his or her horror story about shooting 300 rolls of color film and only later discovering that it had a decidedly green color shift. So you can see why I recommend Kodak's handy pair of exposure aids.

7

Getting Started

A PERMANENT TABLE-TOP STUDIO

IDEALLY you'll be able to find space so that you can set aside a permanent area to be used for photography only. If your craft pieces are small, this "studio" will be on a table top. Whether it is or not, you'll find permanence to be a great convenience. You've finally perfected a piece you want to enter in a juried show whose deadline is almost tomorrow? Just move into your studio and shoot a few slides.

If you'd like to set up a studio area, keep the following requirements in mind:

- Obviously the size of your work will dictate the size of your studio, but try to keep the studio small enough so that it really can be permanent;
- Set it up with a controlled lighting situation so that you need not bracket your exposures widely, and so you can be sure you will have uniformly rich, color-correct rendition;
- Be sure the studio is flexible enough to allow you to shoot dark objects against light backgrounds and light objects against dark backgrounds with equal ease;
- Make sure the lighting is intense enough to allow depth-of-field control at moderate shutter speeds;
- See to it that the studio is absolutely safe to work with, posing no danger to you or your work, or to your studio's electric wiring.

Your studio will consist of a bare wall with a table placed in front of it; a variety of solid-color paper and posterboard, twice the size of your work, for backgrounds; lights; a tripod; and, obviously, your camera with a cable release. That's it. A soft box, as I'll be explaining, is helpful but not essential.

For the table, something about thirty inches high is best; if you are shooting fairly tall objects, use a table, even if it's low, because shooting from the floor makes it difficult to properly align the camera and lights. As for background material: art supply stores will provide you with the paper. One of my personal favorites, however, is a matte "black velvet" paper that makes objects appear to float in space and can be purchased in most larger costume and display stores. More on that later in this chapter.

So. You're on your way.

For your first attempt select four or five pieces to photograph and load your camera with a 24-exposure roll of film. Slide film is the most difficult film to use, showing every mis-exposure and color shift, so once you can produce good color slides, black-and-white and color-negative work will be easy.

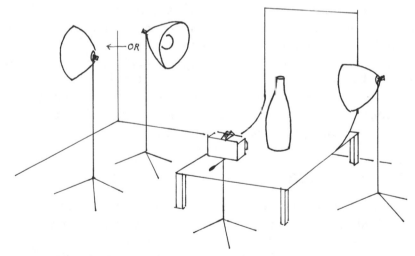

Basic studio setup. To bounce lights, turn either or both lights toward a nearby wall or use photographic umbrellas.

Therefore let's assume you're going to load the camera with Kodachrome 64 and use blue tungsten bulb floodlights, or with Ektachrome 160 T and use clear bulbs.

Tack a sheet of background paper to the wall, let it fall to the table, and drape the rest of it over the table. Don't let a "horizon" show where the paper curves onto the table. Put your work on the table, a bit forward of the center, and set up the camera and the lights. Use two matched lights and set them at the same height — about three feet above the piece being photographed.

Attach the cable release to the shutter button and advance the film to frame #1. Now move the camera until the work is properly framed. Usually you will want to have as little background showing as possible.

You'll want your work to be evenly illuminated. Later, after some experience, you might want to experiment with uneven lighting, but for now you want the same amount of light coming from each side. This is easy to check. Just aim the lights at the middle of your piece and then put a pencil and a piece of white paper at that middle point. Holding the pencil against the paper, perpendicular to your work, make sure the two shadows cast by the pencil are equally dark. If they are not the same readjust the lights. Take an exposure reading, make a picture, and bracket your exposures.

Basically, that's it. Everything else is pretty much a matter of refinement. Just remember, no matter how skillful you become, always to hedge your bets by bracketing your photos — shooting not only at the meter-recommended setting but also at one or two stops more and less.

BOUNCING YOUR LIGHTS

Here's your first refinement: bouncing your light.

Most people, when taking indoor photos, point their cameras and lights directly at the subject, but it is much better to bounce the light off a white wall or the ceiling. This reduces the harshness of the flash and bounces some light into all the surfaces. Simply point the lights away from the work,

toward the walls or ceiling. (You'll lose two or three F stops of light intensity.)

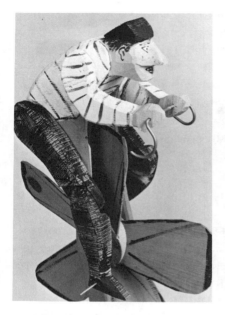 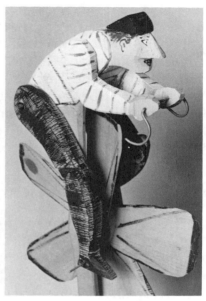

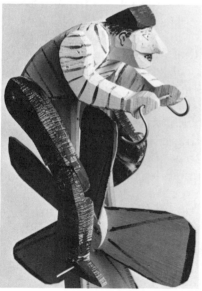

Once you're familiar with your basic studio, you may want to get different lighting effects by placing the lights at different distances from the subject or by using only one light. The upper left photo shows the wooden whirligig in a basic setup with the lights at equal distances from the subject. Above right: illumination is from the left only; bottom photo, from the right only. In these pictures the light was bounced off silvered umbrellas. (Artist: David Lesser)

Often press photographers, when they often don't have a convenient wall or ceiling to bounce the light off, tape a white card (about the size of a 3 " x 5 " index card) to the flash to make a portable wall. This works particularly well if you have a flash with an adjustable "cobra" head, but can't be done with a conventional flash. Point the head straight up and tape a white card to it at a slight angle over the flash tube. The card will scatter and soften the light. There will be some loss of intensity, but the photos will be more pleasantly lit and more natural in appearance. In a studio, many photographers like to use specially made umbrellas with silvered surfaces to bounce the light off of.

A "BLACK VELVET" BACKGROUND

Every once in a while I am surprised anew at how the best things are often the simplest. This is continually true in photography. I often shoot crafts with a remarkably simple set-up that produces some extraordinarily fine images.

This method involves the use of black flocked paper, which comes in 44 " widths from costume and display stores and sells for about $6 to $8 a yard. The usable side of the paper has a surface that feels and looks much like velvet. The important factor to you as a photographer is that this surface reflects very little light (saving you lots of problems with unattractive shadows) and photographs as a lush, rich black (giving you very dramatic slides).

Use the paper like regular background paper, hanging it from the wall and draping it over the table. Because the paper soaks up light you won't have to worry much about stray shadows on the background. Set up your table-top studio, and bounce the light off the ceiling or a cardboard reflector. This works especially well with a soft box (following section).

The only problem with this method is that of exposure. Built-in camera meters seeing so much black will try to make the black a grey. To get an accurate reading there are three ways to go. First, you can move the camera very close to the object and try to get a direct reading off it.

Second, you can use a hand-held *incident* light meter, which reads the amount of light falling on a scene rather than the amount reflected from it. For multiple-light set-ups or unusual situations, this kind of meter can be more accurate than the reflected light meter readings such as those given by camera meters.

The third method is to use your camera meter and an 18 percent Neutral Grey Card. Place the card in front of the object and move the camera until the card fills most of the viewfinder, and then take your exposure reading. And of course bracket your exposures.

Flocked paper is wonderful stuff. Its rich blackness makes the colors of your work pop off the slides. All sorts of objects work well on this background. Wooden objects, gold and silver, and lighter-colored sculpture pieces look great on it. Dark-colored objects will get lost, though, so I wouldn't use it with some woods, glazed pottery, or darker-toned fabrics. But it is superb for those crafts which have bright colors or lighter tones.

One word of caution. Flocked black paper not only soaks up light but it also attracts dirt, fingerprints, and scuff marks. It must be handled with a lot of care.

THE SOFT BOX

The soft box is a very useful piece of equipment that broadens and softens studio lighting — creating what professional photographers consider to be the indoors equivalent of the soft rich light of an overcast northern sky. It can be used either with an electronic flash or a large floodlight, and is particularly useful with surfaces that are shiny or highly reflective.

A soft box looks like a pyramid with its point cut off. The wide end is covered with some kind of diffusing material, usually white mylar. The narrow end is open to accept a flash head or reflector unit. I've drawn a diagram to show the basic shape of each of the four sides of the box.

Although a floodlight can be used with the soft box, an electronic flash is preferable because its short cool intense light is much more suitable with the Foamcore board often used to

build soft boxes. You might use a small 100-watt bulb in place of the flash in the soft box while you are setting up your work so that you can judge the lighting effect of the box. When you are ready to shoot, remove the bulb and put in the flash.

Any automatic flash such as the Vivitar 283 works very well with a soft box. The unit's light sensor can control the flash exposure and, when placed on the camera away from the flash, will insure the correct exposure on every frame. A manual flash can be used, too, although you might need to experiment a little to calibrate the exposure. Figure the correct exposure as given in the flash's instructions and open the lens wider (up two aperture stops as a first exposure), and then bracket a few frames.

The soft box creates a smooth illumination which will fill in the curves and lines of your work, and it is an excellent light source for portraiture.

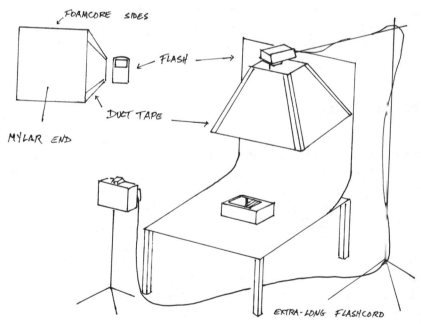

Soft box with flash. In this case, an extra-long flashcord (available where flashes are sold) is used.

Building or Buying

Soft boxes are commercially available, but you might want to consider building one yourself; it's not difficult. Material such as Foamcore (a lightweight mounting board) is perfectly suitable, and can be taped together with duct tape. If you want extra support and rigidity, a lightweight wooden frame can be built around the box. But for a small unit, with a front end about 24" square, duct tape will be fine. Cover the front end with white mylar, which should be available at the store that sold you the Foamcore, or use one or two layers of a much-washed white sheet or any of the several types of translucent plastic available from art-supply stores or display houses.

Attach your light to the soft box with more tape, or mount Foamcore across the narrow end of the box, cut a hole in it, and insert the flash head.

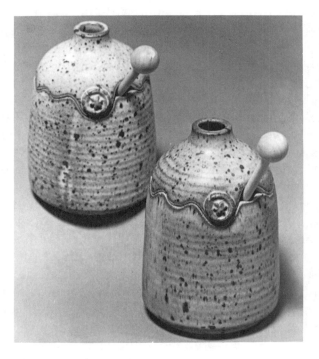

This photograph of two honey pots was done with a single flash in a homemade soft box. (Artist: Stoner Pottery)

If you want to consider buying a soft box you have a couple of choices.

Larson Enterprises (P.O. Box 8705, Fountain Valley, CA 92728), which provides several types of light devices for the photographer, has a line of soft boxes designed for use with either quartz hot lights or electronic strobes. The boxes range from a mini-box that fits on a small camera-mounted flash to large "wall-of-light" models. The boxes are metal-framed, and the diffusing surfaces are flameproof cloth. While the small units are fairly lightweight, the bigger units are not very portable. The Larson boxes have been around for a few years, are reliable, and cost approximately $100.

A new kid on the block, Chimera (P.O. Box 9, Silver Plume, CO 80476), makes "lightbanks" out of lightweight aluminum and Fiberglas rods (such as used in ultralight aircraft) and spinnaker sailcloth.

The light diffusion provided by the sailcloth is broad and uniform and absorbs ultraviolet light. (Reducing the ultraviolet content of strobe light tends to make it less blue and more neutral in color.) These lightbanks are quite like backpacking tents, and they seem to be as lightweight and portable, too. As for cost, they start at about $100 for small units and cost more as size increases.

The Chimera item I find most intriguing is the Empyrean Lighting Dome, which looks like a large white two-person tent and has four shock-corded Fiberglas wands making up the frame. The dome features Velcro-edged panels that open in the front and rear. The front panels provide shooting windows of varying sizes while the rear panels can be removed to allow a background paper to be used. The dome weighs only 4 pounds and measures 42" x 58" x 32". Since lights are placed outside the dome, either electronic strobes or tungsten hot lights can be used. And since the craft object is inside the dome, there's no problem with accidentally having walls or other outside objects appearing in the picture, reflected in your work. But the Empyrean Dome is a high-quality professional unit costing about $423 — probably not what you want now, but worth knowing about if you find yourself becoming an expert. It *is* worth the money.

Black Velvet Paper with the Soft Box

One of the setups I like most is black velvet paper in combination with a soft box. When I shoot this way, I shoot from *under* the soft box, which is set up almost at the camera but at a height of about seven to eight feet. This really gives a daylight feeling. But since there is no light being reflected from the background onto the object, you have to be careful to illuminate the object directly and completely. Sometimes a small white card can be placed (outside the camera's view) to kick a little extra light into any darkish corners.

8

Coping with Glare and Reflection: The Light Tent

HIGHLY glazed porcelain, three-dimensional colored glass, and metallic surfaces may be the toughest challenges in craft

Highly glazed, shiny plate shot with diffused soft light. A small bit of glare (on the left of the plate) adds sparkle to the image. (Artist: Paul Lewing)

photography. They present two separate difficulties that must be dealt with: glare and surface reflections.

GLARE: SOFTER LIGHTING

Glare is actually the reflection of your lights on the surface of the object. The intensity of the light burns out all detail and leaves you with a harsh white spot on the surface of the work.

Glare spots are best reduced by carefully controlling and softening the light. Bouncing your light off large white cards or a white ceiling or photo umbrellas will diffuse and soften the light. This softening will subdue glare on all but the most highly reflective surfaces.

REFLECTIONS: THE LIGHT TENT

Shiny surfaces act as mirrors; besides reflecting light sources, they will reflect your studio, your camera, your dog, even you behind the camera — parts of your life that you don't want in your juried show slides. So how do you handle craft objects with shiny surfaces?

The perfect way to photograph a very shiny object would be to put it inside a translucent sphere that is uniformly lit from all sides. Since such a sphere and light source don't exist, we are forced to use a second-best solution: the light tent.

With a light tent, the object is inside the tent, the light outside. Simply a framework made of dowels with two translucent plastic or fabric sides and top, a light tent creates a uniformly diffuse light environment for shooting shiny objects. The sides of the box can be from 1' to 5' long. The box is open on the bottom and at the back (so that you can use whatever background material you want) and is open at the front for the camera.

Place an object on your table top in front of your background; put the light-tent box over the object; focus; turn on a couple of 500-watt floodlights positioned on either side about three feet from any of the light tent surfaces; take an exposure reading — and shoot.

For many craft pieces, that's all you need to do, but if you're shooting something that's reflecting you behind the camera, you can take a large sheet of white cardboard and cut a hole in it just big enough for the camera lens. Place the cardboard in front of the camera and shoot through the hole. By watching the reflection in your work you'll be able to adjust the cardboard position until you and your camera are completely hidden.

Highly reflective objects will reflect any seams or joints in the light tent, especially the horizon where the sides meet the table top. But if you watch the reflections of the joints and the horizon line on the piece as you move the camera to higher or lower angles, you'll be able to find a position at which these lines are the least visible and from which you can shoot successfully.

You may find that the very whiteness of the walls of the light tent will reflect in the object's shiny surface as white and wash out the features of the object's surface. This is a particular problem with silver or mirrored surfaces. In silver jewelry, for example, you can easily lose the separation between overlapping edges of the piece as all the reflections merge together.

A clever way of dealing with this problem is to cut out long black strips of paper, perhaps an inch wide and a foot long, and tape them to the inside walls of the tent. As you look through the camera you can move the strips until the reflection of a strip is at an edge on the piece to be photographed. The reflection of the black strip is black and will trick the viewer's eye into seeing a distinction between adjacent surfaces.

This also works well on shiny round objects to emphasize three-dimensionality. Normally a large white surface reflected on a shiny ball shape will photograph as an almost *flat* surface. It will be very hard to see the roundness at the surface of the ball nearest the camera. A black strip (or any dark color you want to use) will reflect as a curved line, giving the eye a cue to the piece's roundness.

Construction

A light tent is easy to build. Many photographers build their own, using PVC plastic plumbing piping. Available at most hardware or plumbing-supply stores, PVC is lightweight, easily cut and glued, fairly inexpensive, and very durable. With twelve 2-foot-long 1/2-inch pipes and eight triple junctions (right angles), you can, in less than a half hour, glue together a framework.

The diffusing material for the tent can be almost any kind of translucent material. A piece of a white sheet, white acetate, heavy tracing paper (if you keep the lights a good distance from the paper), or similar material will work fine.

Cut the material to fit the inside of the pipe framework, and glue the two side pieces and the top piece to the piping. You can also glue the transparent material onto the back and bottom, leaving only one side open — the front, for the camera.

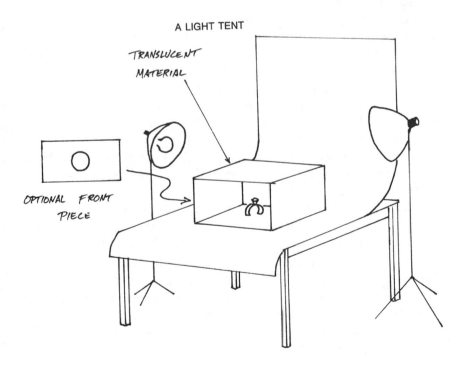

A LIGHT TENT

TRANSLUCENT MATERIAL

OPTIONAL FRONT PIECE

With a bit of experimentation with color balance and exposure, you'll soon feel comfortable with this useful — for some people, essential — device.

OTHER WAYS TO USE THE TENT AND LIGHTS

There are several ways to vary your use of the light tent. One method that works particularly well with ceramics is to use only one light on one side of the box to emphasize form. Although you will still have a diffuse light source illuminating the work, you will have some shadowing on one side of the piece. This will enhance the shape and clarity of the lines on certain objects. Small sculpture pieces may be treated this way too.

Another possibility: use a 500-watt light on one side, a 250-watt light on the other side. This will reduce the depth of shadow you'd get from one bulb alone, but still allows some shadow to create form.

Don't restrict yourself to using the tent simply standing up all the time. You might want to illuminate a craft piece from underneath — a large bowl, for instance. Take the three-sided light tent and set it on its side on a large piece of glass. The top of the tent is now the background.

Pile up some books or other sturdy objects to create two pedestals about 1 1/2 feet high and two feet apart and place the glass across them. Set up a floodlight — or better yet an electronic strobe — underneath the glass, and you're ready to go. Just remember that the floodlight gets hot, so it shouldn't be too close to the books.

The side of the tent that is now the top will reflect a bit of light onto the top of the piece. Your light tent is now functioning in an entirely new way — as an illumination table.

One reminder: the light tent will only be as good as the lights you use. Floodlights, remember, change color with time. After perhaps a dozen hours of use they begin to become warmer in color, shifting to the red end of the spectrum. Film is very sensitive to this shift, and the colors of your work will not turn out accurately. Bulbs are not very expensive compared

to the cost of film. Change the bulbs often, especially after long shooting sessions. Also, floodlights are very, very hot, so don't touch the reflectors to adjust them after they have been on for a while.

9

Shooting Glass

HONESTLY, I grit my teeth every time a craftsperson calls and asks me to shoot glasswork. After nearly ten years of photographing crafts I still find glass to be the greatest challenge and the greatest frustration.

Glass presents all the problems of other highly reflective surfaces and the additional problem of translucence. In shooting glass you must not only worry about seeing yourself and your lights reflected on the surface of the piece, but you have to light up the object so that the viewer sees the light flowing through it.

Stained glass illustrates the problem. A good photograph of stained glass must show the richness of the individual pieces of colored glass and yet show some of the surface texture of the work. It's very tricky. Too much light coming through the glass will wash out the surface textures while too little will make the colors murky.

Clearly the photography of glass requires special attention to the fine control of light and, although they may seem difficult at first, the methods I'll describe for photographing glass should allow you to successfully photograph your glasswork.

The key to photographing glass is to create an environment of soft diffuse light with controlled direction. This will become clear as we go on to specific setups.

FLAT PIECES

Getting back to our stained glass, here's one way to

approach the problem. It's especially successful with flat unin-
stalled pieces of moderate size and can also be used with other
flat glass pieces such as small beveled windows.

This method requires two lights and two large poster
boards, one white and the other white or, in some situations,
colored.

The poster board should be as large as possible, but *must*
be at least four times larger than the piece to be shot. Stand
the posterboard up so that the two pieces are parallel, white
surfaces facing each other, about three or four feet apart. These
will be behind and in front of the glass. You'll need to cut a
hole about two inches in diameter in the front white board for
the camera lens and you'll need to jerry-rig a way to hang or
support the glass between the boards so that its center is level

PHOTOGRAPHING UNINSTALLED FLAT GLASS

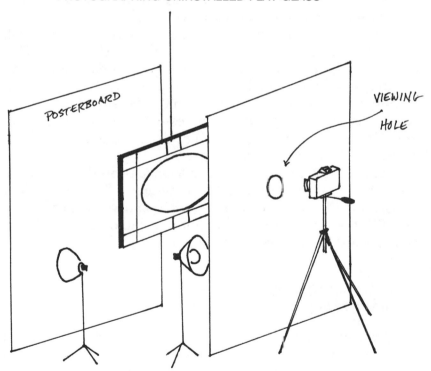

POSTERBOARD

VIEWING
HOLE

with the hole for the camera lens. The glass should be positioned so that when you look through the camera viewfinder you should see all of the piece. If you don't, move the camera and the board back until you can see the whole piece.

Set the lights between the boards, one light pointed at the front white board and the other at the rear one. You are, of course, lighting up the *inside* surfaces of the boards. The light bouncing off of the front board will create a diffuse white area to fill in the surface texture on the piece, while the other light illuminates the rear board to create a circle of light which is transmitted through the piece. This backlight creates a very soft diffuse light environment.

To get a correct exposure reading you will just have to experiment. The trick is to move the lights until you get the proper balance between the reflected light and the light coming through the glass. I do this by getting an exposure reading for each light, one at a time. With the backlight off, the front light reading is taken and then vice versa.

Since the light coming through the glass tends to wash out surface detail, I set my exposure with the front light. This gives me a correct exposure for the surface detail and then I get the backlight to read about a stop lower. Since the light coming through glass may vary with the density of the glass's color, it is wise to experiment and establish your own ratio of light levels between the front and back. Clear glass needs less backlight than deeply stained glass.

Stained glass works best with a *white* posterboard for the rear reflector while a blue reflector creates a "sky" with clear glass. Experiment with your own work to find which colors work best. With a very intense backlight you can even use a black posterboard for very dramatic images.

THREE-DIMENSIONAL GLASS: SILHOUETTING AND HIGHLIGHTING

Let's move now into three dimensional work and build on the preceding two-dimensional technique. If you produce strongly vertical glass pieces (vases and the like), then simple

variations of the flat-glass technique should work for you. One is the "silhouette" method, the other the "highlight" method.

The silhouette method emphasizes the form of a piece; as the name implies the glass stands out as a dark shape against a light background. It's a simple technique.

Place the work on a plain surface (a pane of glass will do) a few feet in front of a white or lightly colored background. Keep the work near the far edge of the surface so that it seems to sit on the horizon line. Light the background with a single floodlight reflector, and you have silhouette lighting. Take great care in metering this setup since your camera meter, "seeing" the spot of light behind the piece, may give you exposure readings which will underexpose the picture. A trick to keep in mind for any sort of backlight situation is to use at least a stop or two *more* exposure than the meter reading. If the meter says F/11 use F/8. And hedge your bet by bracketing your exposure, of course — shoot at F/4 and F/5.6 and F/11.

The highlight method is the reverse of the silhouette, and

Glass jar highlighted against a black background and illuminated from below and behind. (Artist: Jon Simmons)

produces a light image against a dark background. It's just like the silhouette method except you use a dark or black background. The reflector light is placed near the background, pointing at and illuminating the piece itself instead of lighting up the background. Again, take care in determining the correct exposure. Since the camera is seeing a dark mass it will tend to overexpose the picture. Therefore give *less* exposure — use F/11 if the meter reads F/8, for example.

With both these methods you may want to use a white posterboard near the camera and reflect some light onto the front of the piece to pop it up a bit.

Squat Glasswork

Squat pieces are a different matter and generally are best photographed with the light coming from under the object. The method for pieces like plates, flattish bowls, etc., combines the silhouette and highlight methods. You use a dark background and you can, if it seems to help the picture, use a spot of light on the background behind the piece. But the main light comes from underneath. Simply place your work on a piece of windowpane glass that is supported at each corner. A glass-top dining table is perfect for this setup but, lacking such a table, I simply use a couple of stacks of books to hold up the glass. Place a large white posterboard below the glass (at least two feet below) and point one or two floodlights at the board. This will light up the piece from below and show a good deal of the translucency of the work. If the piece is dark glass, you might hold a white reflector, or another light, over the piece to fill in any surface textures that are important.

MOUNTED STAINED GLASS

The public library I use has a large stained-glass window in it that was commissioned by the local arts council. It's a marvelous addition to the building, which is one of the city's earliest libraries. But when I had to photograph the window I was less than thrilled with the conditions I faced. Under the best

of conditions — a studio with controllable lighting — glass can be a challenge to photograph. Out in the wild world it can turn into a nightmare.

The major problem in any glass photography is balancing the light *transmitted through* a work with the light *reflected off* its surface. With a stained-glass window the surface texture may not be critical, but it is generally absolutely necessary to show the setting around the windows. The problem in shooting stained-glass windows is that the correct exposure for the windows usually produces a picture of the windows floating in total darkness; if the exposure is set for the proper reading of the room, the windows are washed out or totally clear.

Color film doesn't have the latitude (or range between under- and over-exposure) to adequately record the scene. It's similar to the problem faced in shooting any glass, but since the sun, in addition to indoor lights, is your light source, it's hard to control your lighting.

Control is a mixture of luck and skill in this case. First of all, hope for a cloudy day. Sunlight coming through the windows will make it very hard to keep the lighter parts of the window from washing out. But on a dark cloudy day the difference between the lighting outside and the light indoors will be less.

As a starting point take an exposure reading of a middle-toned section of the windows. It needn't be an exact middle tone but it shouldn't be either the darkest or lightest piece of glass. Then step back to the place from which you want to take the picture and get a reading of some middle-toned part of the room. Don't read off white walls or lighted lamps, but find something in between.

Now compare the two readings. They should be as close as possible. For example, if the window reads F/11 at 1/2 second and the room reads F/8 at 1/2 second you are in business. If you shoot at the correct window exposure, the room will be only slightly dark. Had the room reading been F/11, you would also have had a good balance. A reading of F/5.6 at 1/2 second for the room would mean that the room would seem pretty dark. If the room reading were F/4 or F/2.8 (that is, the room needs three or four stops more exposure than the windows), the room will be pitch black.

Of course you can use a flash or blue floodlights to raise the light level of the room inteior, but remember you must use *daylight*-balanced color film for the windows. Rooms illuminated by small lamps or clear tungsten floodlights will record with a distinct reddish coloration. (However, this warm color is not necessarily bad if your concern is the window.)

Double-Exposure Technique

While the preceding method produces good photos, there's another method that is sometimes used which requires less calculation but greater patience. Just set up your camera on a good rigid tripod, and get a daylight reading off the window (still a middle tone) and make an exposure. This is the "windows floating in blackness" shot.

Now use the double-exposure override on the camera to re-cock the shutter without advancing the film. Then go away. Don't move the camera, don't even touch it. Come back at night and turn on the room lights, and, carefully finding the correct exposure for the room without moving the camera, make a second exposure on the same frame. The resulting double exposure will look like a single picture of a room with very nice stained-glass windows.

Only you will know what sort of craziness it took to tame the glass beast in its natural setting.

10

Special Challenges: Tiny Objects and Light-Containing Objects

ALMOST from its start, photography has been used to open our eyes to the world of the very small. Louis Jacques Mande Daguerre, the man who made the first practical photographs, was reported to have produced daguerrotypes of a dead spider through a "solar" microscope as early as 1838. The fascination with pictures of the very small has also advanced whole fields of knowledge such as biology, geology, and medicine. But if you are a craftsperson photographing tiny objects, the world of the small can be a nuisance.

THE MACRO LENS

The ceramic winged pencil in the photo is a pin that measures about an inch and a half in length. Notice how it fills the frame so that you can see it clearly enough to know what it is and see all its detail in great sharpness.

This picture was taken with a single-lens reflex camera with a 55mm "macro" lens, 35mm high-speed black-and-white film, and one hand-held electronic flash. Oh, yes, and three tissues. Pretty exotic, huh? It's my way of showing that good-quality photography of a tiny object does not require a great deal of sophisticated equipment. It obviously requires some equipment, but hardly out of reach for the average craftsperson.

What you need for shooting very small objects is a *macro lens*, which is simply a lens with an extended focusing mount

Two-inch-long ceramic pin shot with a macro
lens. (Artist: Lou Scorca)

that allows the lens elements to move close to an object and
farther away from the film than the usual standard lens. If you
are a jeweler or a maker of ceramic pins or any other small
object you will absolutely need a macro lens for your
photography. I find that a good macro lens works better than
a standard lens on extension tubes or a bellows (described in
the following section), and far, far better than close-up lens
attachments. A macro lens will focus continually from infinity
to perhaps two or three inches from a subject. At three inches
a macro will let you fill the frame with an object about two
inches long!

For the winged pencil shot I placed three layers of tissue
over my flash unit (a $50 cobra-head flash), set the auto set-
ting on the strobe to F/16, held the flash at arm's length from
the piece, and fired away. My camera's flash setting of 1/125
second, and the high speed of the flash (about 1/20,000 second)
allowed me to easily hand-hold the camera. I focused the lens
at its extreme close-up position and set the aperture to F/16
and, watching the image in the viewfinder, moved the camera
near to the piece. When I had the piece clearly in focus I snapped
the shutter and, *voila*, the picture you see.

The tissues over the flash head is an old photographers'
trick to soften and diffuse the light. Since the winged pencil

had several silver and gold glazed areas that were highly reflec-
tive, this diffusion was necessary.

Without a macro lens I wouldn't have been able to get
closer than say eighteen inches or so. At that distance the pencil
would have been about a tenth of the size it appears in the
photo. It would have looked like nothing. You just gotta get
close.

Extension Tubes and Bellows Units

Most macro-type lenses can only get so close, usually to
half of lifesize, and no closer. An object about 2" x 1" will more
or less fill the frame. That's fine unless you make earrings such
as jewelled studs with tiny gems, perhaps half of an inch across
or smaller. For objects that small, a macro lens won't get close
enough to produce a photo that shows any detail.

A special challenge in my own experience was a miniature
painting that measured an inch-and-a-half square *with* its frame.
I photographed the framed painting with my macro lens at its
maximum magnification. But I also wanted to get a shot of the
painting alone. Since the painting measured only three-quarters
of an inch wide, I needed to get at least twice as close to show
any detail.

To do this I could use one of two devices. Both accomplish
the same job — they move the lens closer to the subject and
away from the camera. One device is a set of metal extension
tubes that fit between the camera body and the lens and, by
moving the lens element away from the film, increase the
magnification. These simple tubes allow you to choose any one
of several magnifications and are relativley inexpensive. A set
that maintains your camera's auto-exposure linkage can be
bought for less than $50.

The second device is actually a variation on the first. A
bellows unit, like the extension tubes, moves the lens away from
the camera body and film. The advantage of the bellows is that
it usually allows greater magnification (because it extends fur-
ther) than the extension tubes, and, since it is movable, offers
a wide variety of extensions, unlike the tubes, which extend

to fixed points only. But it also costs twice as much as the extension tubes.

Useful though they are, these devices do have drawbacks. As the lens moves away from the film the intensity of light on the film diminishes rapidly. Move the lens one to two inches from the camera body and you need four times as much light for the same exposure. With a three-inch-long extension tube you need at least three stops more exposure, or eight times as much light. And you can't simply open the lens diaphragm to let in more light because at wide apertures (F/4 or even F/5.6) there is so little depth of sharpness (a few millimeters at most) that you won't get a usable image. When you use a bellows or extension tubes you need lots of light close to the subject.

For my photo of the framed miniature I used a 500-watt floodlight about two feet from the painting. My exposure was 1/4 second at F/16 with a high-speed ASA/ISO 400 black-and-white film. But the close-up of the painting alone required an exposure time of about four seconds at the same aperture, or sixteen times as much exposure.

Painting 3/4" wide photographed by using an extension tube. (Artist: Branko Bijelic)

So I had to consider reciprocity failure: the inability of the film to work right at long exposures. At these exposures (above a second or so) you have to use even longer exposures than what your exposure meter reading tells you to use. For example, your camera meter may say that F/16 at one second is the correct setting; however, the film's reciprocity failure will cause that reading to produce a drastically underexposed picture. You'll need to experiment a bit with either bellows or extension tubes to get a feel for how much exposure compensation you'll need.

Although the use of these devices may seem complicated at first, they can open up a whole new world for you. You'll be able to fill your slides with the smallest object, and when these images are projected your work will be magnified twenty or thirty times life size on the screen. It's impressive, and with luck will impress lots of gallery owners and show judges.

OBJECTS CONTAINING LIGHT

Now, having coped with work that is unusually tiny, let's move on to objects that contain their own light. This challenge came to me when West Coast artist Leslie Liddle brought some of her pieces to my studio to be photographed, among them several wonderful ceramic nightlights. Her timing was good because I happened to have nightlights on my mind. My five-year-old daughter couldn't get to sleep in the dark, but the only nightlights I could find for her were small boring plastic ones. So Leslie Liddle, complete with her nightlight challenge, was especially welcome.

The challenge that photographing nightlights presents is similar to what other craftspeople may run into if their work contains any kind of light, as a candlestick or small lamp would. Candle holders with unlit candles are not very interesting and certainly a darkened nightlight isn't much of a light. After all, how is a show judge to tell what your work's about. So the trick to photographing these pieces is to make the candle or the electric light appear not only to be lit, but seem to be the source of light in the picture.

Of course, there's no way you'll produce a high-quality picture by candlelight or by the light of a small lamp. First, the lights are often inside of the holders, and second often they are far too warm (too red-producing) for any kind of film to record the colors accurately. And, obviously, they don't produce enough light. On the other hand, if you light up the pieces, the lamp or candle will not appear to be lit.

So what's the magic method for dealing with illuminated crafts? It's pretty simple, but it does require a small electronic flash.

Set up the piece and plug it in or light the candle. With the room lights low get close to your piece and use your camera's built-in meter to get a reading for the light. You don't even have to be able to focus the lens that close, just try to read the light by itself. Typically a 7-watt electric light might read F/11 at 1/4 second with a film like Kodachrome 64. Now move the camera back to your shooting position. Place the camera on a tripod, and frame and focus the image.

Since you want the light to be lit, in this example I'd set the camera to F/8 at 1/4 second (at this shutter speed the electronic flash will be correctly synchronized with the camera). If the strobe is set to F/5.6, the picture will now show a slightly dark piece with a bright light inside.

As usual, you need to bracket exposures. But in this instance, rather than changing aperture settings, change the shutter speed and flash setting. Changing the shutter speed will change the lightness of the lamp or candle. Because most cameras require a shutter speed of 1/60 or less (that means slower) for flash synchronization, you can go from 1/15 to 1/8 to 1/4 to 1/2 without affecting the flash exposure.

What this method really involves is making two pictures simultaneously on one frame. So, while the shutter setting will only increase or decrease the level of light from the lamp or candle, the flash will control the brightness of the outside surfaces of the piece. Because the picture shows the lamp or candle as the light source, the piece itself should be underexposed a little. Most modern flashes have automatic settings, and for a particular film you usually have a choice of three or

Eight-inch nightlight shot using illumination from the nightlight's tiny bulb and a hand-held flash. (Artist: Leslie Liddle)

four aperture settings for your lens. To bracket the level of light on the piece, change the flash settings without changing the aperture setting.

Bracketing both the shutter speed and flash setting is unusual but it's necessary because you have two light sources. That's a lot of frames to shoot; three flash settings at each of three shutter speeds means nine pictures to get one that's correct. But if done right, you'll produce a pretty spectacular picture to send out for jurying.

Oh, yes, since an electronic strobe produces a very harsh light, try bouncing the light off the ceiling or a white card to soften it. After all, candle holders and nightlights should look the way we expect to see them — gentle and comforting for the soft, late hours of the day.

11

Taking Pictures That Are Special

I'VE taken up a lot of space to cover equipment and technical information because without them you can't get your work where it belongs. But sometimes the less tangible aspects of a photograph are what really give it an edge and give the photographer some fun.

COMPOSITION

I'm often surprised that some of the most successful crafts-people I know can win awards for design, yet find it impossible to compose pleasing pictures. It's as though when looking through a viewfinder they forget everything they know about form and light.

I am certainly not one to leave my friends in the lurch, so here's a list of some basic elements of good photographic composition. In a good photo you should:

- Imagine the frame divided like a tic-tac-toe board;
- Have a strong center of interest;
- Select the best camera angle;
- Move in close and fill the frame;
- Use strong lines — curves or diagonals — to focus interest and create unity;
- Simplify your backgrounds.

Even in a simple photo — for example, a carved box against a plain dark background — you should try to have a single point of interest. In this example, perhaps there's a really

unusual carved figure that can be the center. With an embroidered blouse or woven rug it could be a pleasing shape or color combination.

It seems obvious, but it is important to carefully select the best angle to shoot from. Camera lenses distort the shape of an object, especially when you are very close. A normal 50mm lens will make an object bow out at its center. This can ruin your skillfully created subtle forms. Thus you need to carefully view your work through the viewfinder and try to imagine how the two-dimensional picture will look. Move the camera and watch how the shapes change; then select the best position.

Move in as close as you can when you photograph your work. Make the work fill the picture without touching the frame edges or cutting off part of the object. Let the viewer really see the object; getting close increases the viewer's sense of intimacy with the work, and that's good.

When photographing a single object it is hard to find very many visual lines on which to focus interest, but they are there. One of my favorite techniques is to use the line of a form — say a teapot spout — to bring the viewer's eye into the picture. By carefully adjusting the positon of my lights, I can get a thin line of light to accent the curve of the spout and focus attention.

Of course, with a group of pieces you can easily line up the objects so as to create strong diagonal lines or pleasant curves for emphasis.

I constantly look for simple backgrounds. Scenic backgrounds such as you find in advertisements are pretty hard to pull off. Too often the scenery in a craft photo detracts from the piece being phtographed; it introduces too many distractions to be worth doing. For example, putting your jewelry into a country setting might tempt the viewer, a gallery owner, to identify the background and overlook the jewelry — even though your work could fit perfectly into her gallery. Simple backgrounds are generally best.

The very middle of the photographic frame can be a terribly "dead" area. The points of greatest visual interest in a photograph are at the intersections of four imaginary lines that divide the frame into thirds horizontally and vertically (like a tic-tac-toe pattern).

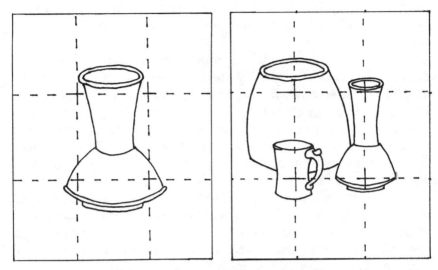

"Tic-tac-toe" lines dividing a frame into thirds. Note that single object as well as grouping are placed at *intersections* of lines.

In practice this means that placing a piece on an imaginary line a third of the way up from the bottom edge improves the image. Or having a pendant hanging at the lower horizontal line with its chain disappearing at the upper corners can make an effective photo.

There's a lot of intuition to good composition, and a lot of trial and error, too. But a strongly composed photograph is worth the effort and will help sell your work.

KEY: MAXIMIZING THE EFFECTS OF COLOR

In color work even the smallest area of a hot color, like a red or yellow, will divert attention from everything else in the picture. Too often photographs of work taken casually in a back yard include extraneous objects that draw our eyes away from the piece that's supposed to attract us. A corollary to this is that dark colors or tones merge together and are lost, simply not holding our interest at all. Photographing a dark-toned ceramic pot can be very frustrating for this reason.

The way to deal with this type of problem is through careful

lighting, perhaps even using a fairly harsh light so as to create some glare spots to hold attention.

Key is the term used in regard to photographic lighting that applies here. High key describes an image in which most colors and tones are very light. There is little or no difference in total intensity. The overall feeling of this type of image is light and airy. It is excellent for light-colored fabrics, glassware, etc. A white porcelain plate on a white placemat on a white table is a high-key image. Add a small touch of black, say a single dark silver fork, and you have an image which is downright elegant.

Low key is of course the opposite. Dark moody tones. Deeply saturated colors, mostly blues and browns. A dark, near-black ceramic bowl against a dark background. And as a counterpoint a small amount of light, perhaps the most intense white from a spotlight outlining one edge of the bowl and spilling ever so slightly into the glazed areas.

ATMOSPHERE

Intangibles like atmosphere affect photographs too. Be aware of composition when you're browsing at your local gallery, specialty shop, or department store. Next time you go to one of these places observe how they display their goods and evaluate their techniques critically. You'll be surprised. Sometimes it isn't the product that's the focus of the display, but the feeling. You'll see that perhaps a sense of elegance or utility or neatness is the focus of the display, and that the objects fit into that.

ADDING SPICE TO YOUR PICTURES

Antique shops fascinate me. Inexpensive curios from the past are not only fun to find but they are a source of great picture elements for my craft photography.

Although lighting and placement are the basic elements in the recipe for strong pictures, now it's time for the spices. For me, antiques are a wonderful spice.

An example of this spicing that comes to mind involves the photography of jewelry. Photographing jewelry is particularly demanding. Most objects are small, and as a camera gets closer to a subject the depth-of-field area that is in sharp focus diminishes.

Gemstones have to be carefully illuminated, and that's made difficult by short distances, too. And with jewelry it seems that an object placed on just a colored background, no matter how well crafted and lit, makes a boring photo.

I recently photographed some scrimshaw earrings and pendants. Although beautifully carved with images of sailing ships and animals, the work looked very flat lying on the background paper. So I reached into my collection of old junk and created period settings for each piece. One of my favorites from that shooting is a shot of a beautiful bone-handled knife resting on the edge of a mahogany desk in front of an old gold-framed picture of a cowboy. Natural light coming through a nearby window was the only source of illumination. The image is very evocative and yet shows the knife clearly: in detail and as the center of attention. The photos were shot for a juried competition and I'm sure that they helped my client get into that show.

On another occasion I put a tiny topaz earring on the ear of a woman in a picture in a 1920s car ad from an old *Colliers* magazine. Angling the light carefully, I caught a bright glint off a facet of the topaz and a slight shadow to give the earring three dimensions.

For a silversmith friend I produced a set of pictures of men's rings, each of which was photographed with old-time shaving brushes and mugs gathered from friends and borrowed from shops. Some were pre-Civil War pieces, others as recent as the 1950s. Thanks to the use of several tiled bathrooms and kitchens, a series of pictures could be shot giving the feeling of candid moments in the morning routines of men long gone. For the pre-Civil War picture I took a ring, an old straight razor, a broken mirror, and the mug and brush and set them by the side of a river, as though some backwoodsman of the 1850s had stopped to clean himself up on the way into town.

Each of the settings I've described tells a story. The story fills in feelings about the piece that could not otherwise be shared with the viewer. They allow the viewer to move back from the piece itself without losing sight of it. These photos, of course, require much more thought than simply placing the piece on a colored background. They also require a little wit to pull them off without being trite. But all in all they are great fun and can produce very striking images. They are great fun for brochures or ads but a little too busy, I think, for good juried show shots.

COLOR DISTRACTIONS TO AVOID

I guess it's obvious that some of the sage advice I'm passing along to you is the result of less than perfect decisions I've made in my own photography. Which reminds me of (among other things) some photos I once shot for a jeweler who insisted on placing her gold and gemstone rings between the petals of flowers. Foolishly I acquiesced to her demand, and the pictures were terrible. The deeply-colored petals were so intense that they overpowered the rings. Furthermore, the gems and rings

Imaginative composition making use of a strong line, in this case a circle. The pieces are ceramic stamps. (Artist: Judith Meltzer)

reflected the colors around them so that each ring had the cast of the flower it rested on.

When shooting color slides you need to consider not only the lighting key but also the colors you are using. Deep, rich colors like rose-red overwhelm anything else in the picture. So do strong patterns, so never put anything on an India-print bedspread to be photographed unless you're more interested in showing the content of your linen closet than your craftwork.

Color contrast, which is what we are talking about, also creates another problem. A photographer might be very conscientious about using the imaginary tic-tac-toe lines that divide the frame in thirds. But the eye-catching pull of deep colors, particularly those at the warm (yellow-red) end of the spectrum, can overpower your important picture element, even if you've positioned it properly in the frame. A red flower with a bright yellow center standing in a vase will tend to dominate the picture even if the flower is way at the top of the frame and the vase exactly where it should be.

BLACK-AND-WHITE PHOTOGRAPHY

The photographer has two main concerns in black-and-white photography: thinking of the black-and-white photo as an abstraction and controlling tonal values.

Removing the color from images allows us to look at the other elements of an object. Without color to distract us we see form and texture more clearly. This means that if you need a strong image for a black-and-white photo for, say, a newspaper or a show announcement, you should photograph a piece with especially good design and shape. When you shoot the photo you'll want to experiment with the light to accent the form. Perhaps using a strong sidelight will give you the proper emphasis. Abstract the object by reducing the image to its basics. While a color photo can stand on its own just because colors are vivid and interesting, the photographer has to do more work in black and white. By selecting an angle or lighting that accents the work you'll produce black-and-white photos that please you.

Generally, in black and white you should avoid solid white or black backgrounds. A neutral middle-tone grey background will be the most successful — it makes your work look good and, if your photographs end up in a newspaper, they will print well.

Using Filters for Tonal Contrast

Black-and-white film, because it can't record colors, renders those colors as grey tones. *Tone* is a measure of intensity, and often adjacent colors will photograph in black and white as the same tone. There will be no separation; they will look like one area. One solution to the tone problem is to use colored filters. A filter will lighten its own color and darken its complement.

For example: You are a weaver and you've got a great piece with strong reds and greens that you want to photograph in black and white. Without a filter, the reds and greens might come out the same tone and the overall pattern of the weaving will be lost. Colored filters screw into the front of the camera lens. In black-and-white photography, filters are used to lighten one color and darken another. A yellow filter (type 15 or G) will lighten yellow colors and darken blue. A red (25) filter will lighten red colors and darken blue and green. For the weaving just mentioned, you might use a red filter to make the red color record as a lighter tone than the green, thus making the pattern clear and strong. The opposite would work, too. A green filter will lighten green and blue and darken red.

Besides recording the colors as more distinct tones, filters will also affect the contrast of the picture and add strong tonal emphasis.

The use of filters for black-and-white photography requires some exposure adjustment. The specifics are usually listed on the filter package. However, if you have a 35mm single-lens reflex camera with through-the-lens metering, you won't have to make any exposure compensation because the camera itself will take care of it.

12

Using Your Photography for Promotion

I LEARNED promotion at my grandfather's knee. He played the mandolin on the Yiddish stage in New York and was billed as Pescha and his Magic Gypsy Mandolin. He was a good performer, with a good billing, and he knew how to draw a crowd because he was always promoting.

Never stop promoting. Once you have good photographs of your craftwork you're halfway there — the pictures will do the promoting for you. Just get them out into the world in as many places as you can.

WEEDING OUT, GETTING DUPLICATES

First, though, go through your slides and prints carefully and pick out the best ones. My definition of a good photograph is one that clearly shows what you want to show and nothing else. Throw away or file in the family scrapbook all the photos that show your work pictured with the family dog, backyard, house, or miscellaneous body parts (no matter how gorgeous).

Remove every picture that is not sharp throughout the depth necessary to show all of the important aspects of your work. Throw out all the pictures that are not correctly exposed. You can identify proper exposure in a print or slide by two characteristics: 1) highlights and white or light tones, which will have a light but visible texture or surface (white paper, for

example, should have a paper surface visible in the picture); 2) clear separation of dark tones. Also there should be richness to the colors (saturation) and tonal differences. Both qualities mean correct exposure and development.

Once you have selected a set of good (no, great) slides or photographs, go to a local processor or a national photo-finishing lab and get about a dozen duplicate sets made. (Slide duplicates will cost about a half-dollar each at most.) The techniques for slide duplication have vastly improved in the last few years. Professionally-done copies should be extremely close to the quality of the originals. While there may be a slight shift in color or a slight increase in contrast, these should be well within tolerable limits and should not adversely affect the use of the duplicates.

In the case of prints, of course, an unlimited number of copies can be made from the same original negative. As for slides, the next chapter explains how to convert them into black-and-white prints.

On each duplicate print or slide write your name, address, photo title, and a notice that reads, "Duplicate — not for reproduction." Carefully store the original slides or negatives in a cool, dark place (see page 108 regarding storage).

PHOTOGRAPHS TO EDITORS

Now that you've clearly identified your slides or photos, get them to the people who might want to give you work: editors of craft publications, ad agencies, gallery owners, art columnists, etc.

When you send the pictures out, your cover letter should tell the recipients:

- Who you are;
- Your credits;
- How long they can hold the slides or prints (14 to 30 days would be reasonable), and that you're including a stamped, self-addressed envelope for returning the photos;

- That you expect the pictures to be returned in good condition and would expect reimbursement of $10 (or whatever) for each lost or damaged photo.

A dozen sets of slides or prints circulating around the country is a good way to use your photographs for self-promotion. Another good way is to get your photos into magazines and newspapers.

FREE PUBLICITY FOR AN EXHIBIT

If you are planning a gallery show, a high-quality black-and-white photograph sent with a short press release to local papers can get you some valuable free publicity. Besides the large newspapers found in most communities, many areas also have smaller neighborhood weeklies or monthlies and shopping guides. The editors of these papers are usually more than happy to run a good photograph with an appropriate caption.

If you have only color slides, have black-and-white negatives made so you can get prints. When you get your prints, type out captions with your name, address and phone number on a separate piece of paper and tape it either to the back or the bottom of the photo. A good caption should be less than twenty words, and all prints should be glossies, preferably 8" x 10".

Do not write on the back of the photo; the pressure of the pen or pencil may show through. Address the envelope before you put the photograph in it, for the same reason. And always include a piece of cardboard at least as large as the photo to keep the print from being creased or ruined in transit. Also, be sure to include a short release telling about the show.

When you are selecting the photo to use, try to pick an image with a light-colored background, with your work in mostly grey middle tones. Dark tones and blacks usually do not reproduce well on newsprint.

POSTERS; OTHER NEWSPAPER PUBLICITY

If you are planning to produce a poster for a show or a special sale you might consider using the same photo as the

one you send to the papers. A key element in any advertising is repetition, and a strong image which appears on posters and in the press is more likely to be remembered.

Try to find reasons for sending prints to newspapers. Obviously, if you win a prize for your work, or are accepted into a juried show, it's news, and a photograph would be welcomed. Bear in mind, too, that you might be a feature story. If, for example, you've been giving successful classes to the handicapped, a feature or news editor might want to know about it. Don't be shy — remember, papers have to fill a lot of space every day. If they want to do their own photography, and the pictures turn out to be theirs, not yours, well, it's great publicity anyway, right?

MESSAGE CARDS, BUSINESS CARDS, AND ...

Another way to use your craft photos is in the form of self-promotion cards. You may have seen the photo greeting cards that photo processors create for the Christmas holidays by taking a customer's slide or color negative and reproducing it at reasonable cost. You can use a similar technique, except that your name and address and a message can appear in the space usually reserved for the holiday greeting.

One hundred such cards with messages will cost about sixty dollars. They come with envelopes and make great full-color promotion pieces you can send to important customers to keep them aware of you. Check your Yellow Pages or a local camera shop for the name of companies that can provide this service in your area. (But shop around; printing costs vary widely.)

Many photographers have business cards which feature one of their photos on its face. A few large color labs in major cities are able to produce color-photo business cards. A good shot of your best work on your business card will certainly dramatize who you are and what you do. Surprisingly, these business cards do not cost more than high-quality printed cards.

There are many other ways to use your photos for promotional purposes. You can have calendars made, or even photo

buttons. It is up to you to figure what route is the most effective and produces the greatest return. Name recognition is a major goal in publicity, public relations, and advertising. For you as a professional craftsperson, the name of the game *is* your name and its association in people's minds with your craftwork.

AN ATTENTION-GETTING PORTFOLIO

Now that you're starting to think about effective ways to use your photography, you'll want to give some thought to your portfolio.

The purpose of a good crafts portfolio should be twofold: It should establish that you are a professional craftsperson, and it should be visually strong enough to be remembered by the viewer. Too often portfolios are a hodgepodge of visual styles, photographs of poor quality mixed with good ones. The worst portfolios are those that show someone's "greatest hits" — the personal favorites of a craftsperson from the last twenty years of work. Let a museum put on a retrospective of your work after you're gone, but right now ask yourself if your portfolio is really a reflection of where you are today as a craftsperson.

Obviously, you want high-quality pictures of your work in your portfolio. But have you considered that pictures of your work tell only part of the story? Your portfolio introduces you, and as part of a first impression it should say a lot about you.

Adding photographs of work-in-progress is a way you can round out your portfolio. You should be able to send your portfolio to a gallery owner, and without you having to be there or saying a word, your portfolio should be able to tell all about you. It should also generate interest in you and your work.

What you need to think about, therefore, is that your portfolio actually be something like an article in a magazine like *Life* or *People*: very little text but good pictures to tell a story. The thread of work in progress can hold the story together. Just follow the old journalism guideline of telling who, what, where, when, why, and how.

The opening pages can show who and where. A photo of you working on a piece in your studio will tell who you are and

give the viewer a feeling for the investment you have in your craft. The picture should show as much of your space as possible. After all, you're paying for the space, you've fixed it up, you've invested a lot of money in your tools. The client-viewer needs to know that. This says that you are a professional and this is your work, not simply your hobby.

Opposite this picture could be a good shot of the piece you are working on in the first photo. This makes the connection between the place where you work and what you are capable of producing there.

Turning the page, the viewer comes to a medium-distance image of you working with a special tool or process. For some crafts this can be a very dramatic shot or at least a very *dramatically lighted* shot. Again the piece you are seen working on in the medium shot should be seen in its entirety in an accompanying shot.

Now you have shown who, where, and what, and you have hooked the viewers into your story. They are curious and really want to look at your portfolio.

Next, you move in closer still. A tight close-up shot such as the one of the silversmith working on a fork shows the care

A close-up shot such as this one of work in progress can be very effective in a portfolio. (Artist: Walter White)

with which you work. It should illustrate one thing — your skill. Again a photo of the completed work, accompanying the closeup, will connect process to product.

If you show in galleries or sell at fairs, you might want to illustrate this next. This tells the viewer why you do what you do, and again speaks to your professionalism. Follow up the gallery or fair photos with perhaps six to ten additional pictures of your recent work to complete your story.

Probably these are all pictures you can shoot yourself, and for the ones that show you at work, you can set them up and get someone else to snap the shutter. (See pages 43 to 44 and 86 to 87 for black-and-white techniques.)

A work-in-progress portfolio is an unusual presentation of your work which should attract attention and separate you from the crowd. The portfolio is your introduction. And after a good introduction you should be able to put on a great show or land a nice commission for your work.

PUTTING IT ALL TOGETHER IN A CATALOG

I am often asked by craftspeople to review photographs of their work, and I am continually struck by the hodge-podge of images I am presented with.

In the first place, it seems that everyone has tried a bit of their own photography *and* used professional photographers, too. The result is a visual jumble that detracts from the craftwork and is probably responsible for some jury and show rejections.

Aside from the mixture of photographic styles, what I'm shown will often not be the best selection of the craftwork itself. A craftsperson usually starts from the fairly general — say, making ceramic high-fire plates — and eventually moves on to a personal style — perhaps large blue-green plates with hand-painted landscapes. If the style is distinctive, people will begin to recognize it. The final step is art, which to me is the evolution of a style to the point of experimentation.

My point is that if you have spent years developing a style — a coherent and consistent set of choices which define your

work — shouldn't the photographs of your work, which represent you, make a coherent and consistent presentation too? I think so, and I think that a catalog is one of the best forms for that presentation.

At some point in a craftsperson's career it is important to have a catalog. It might be for wholesale use or retail sales or for a show, but in any event it is a statement about you and your work and a benchmark in your career.

Costs

In discussing putting together one's work photographically, I intend to be as realistic as possible. Therefore the place to begin is at the bottom line — the cost.

A photograph that would be a lovely addition to a catalog. This provides a personal touch — partly showing the ceramacist's face — as well as scale for the delightful tiny teapot. (Artist: Ulla Winblad-Hjelmqvist)

Few craftspeople can afford photographs of every item they produce, nor would it make any sense to pack a catalog with hundreds of similar items. So let's set some limits on this project. I think that a good catalog or portfolio should be able to present someone's work in twelve to twenty-five photographs. The cost of getting that many pieces shot and printed will vary, naturally, but should be within the budget of a professional craftsperson.

Since a catalog is a sales tool, you will expect it not only to pay for itself but to produce a reasonable return for the work.

The most realistic way to start is to ask, "How much do I have to spend and what do I need?" Here are some things to consider in trying to come up with what you need. Most of the costs of a catalog are front-end costs; that is, whether you print one catalog or ten thousand the basic cost of photography, typesetting, layout, and negatives remains the same. Producing lots of catalogs spreads out the cost and reduces the cost per unit. If you are going to do a catalog you should probably check your mailing list and decide how many catalogs you're going to need. A simple 8 1/2" x 11" eight-page catalog in full color can easily cost $5,000 just for camera-ready material. Printing and paper costs could easily double that. If your mailing list is less than a thousand names, is it worth it for you to spend $10 a copy for catalogs? Probably not.

The same catalog in black and white may only cost a $1,000 to get camera-ready and a few hundred dollars to print. Is this an option for you? The choice of black and white versus color is a major decision. Everyone likes color but can you afford it? In black and white many crafts look just fine if their strong points are form, unique elements, and function. However, if subtle colors are the distinctive part of your work, you will have to use color photos.

Underlying this discussion is the assumption that you'll produce enough work to support catalog sales. It's senseless to send out catalogs of your work if you have only a few one-of-a-kind items. If, on the other hand, you produce lots of work and in good quantities, then one of your concerns should be what to include in the catalog and what to leave out, since one

of the factors affecting costs is the number of photographs you use. For each black-and-white photograph in the catalog a half-tone screened negative must be made. This can cost from $5 to $25 each, depending upon the printer you use. Color photographs require four separation negatives per photo and they can cost anywhere from $50 to $500 each.

Cost-Cutting

There are several ways to cut costs. You could have five or six pieces in a single photo and have just a few large photos in the catalog. Your catalog dimensions needn't be large; 5 1/2 " x 8 1/2 " is attractive. You could have six or four pages, or simply a single-page flyer. You could have some color photos, and some black-and-white ones (in which case, be sure all the color pictures are on the same pages when printed, to save money).

Educate yourself by talking to printers and typesetters; explain that you've got to keep costs down, and learn about the best buys in paper quality and sizes. Shop around: typesetting costs vary and printing costs do even more so. Be aware that when you're talking about pages with a printer what you probably think of as eight pages is sixteen to a printer — since pages are numbered on both sides — so be explicit. Find out about stapling costs, too. Study the catalogs that turn up in your own mailbox.

You might also check into one of the large printing houses that specialize in full-color catalogs at very low prices. They have only a few styles of brochures or catalogs available, but you can save 50 to 70 percent of the printing costs this way. Two of these printers are McGrew Inc., P.O. Box 19716, Kansas City, MO 64141 and Dexter Press, Rte. 303, West Nyack, NY 10994.

Keep mailing costs as low as possible. If you mail 200 or more catalogs (or anything else) at a time, you can send them at the bulk, presorted rate, but you must buy a bulk-rate inditia ($50 for one calendar year) and must print your permit number on the address side of the catalog or on the envelope that

will contain the catalog. Before making a final decision on paper and number of pages, *weigh* the paper after cutting it into the exact size and number of pages you're considering; you might want to make a change to get the best postage rate. Again, ask questions; post office personnel know the answers and have brochures they can give you.

Difference Between Catalog and Portfolio Shots

Catalog work differs from portfolio and juried show photography because images in a catalog need to relate to each other as a coherent presentation, as well as conveying something about the particular style of the craftsperson.

In sales catalogs the images must not only hold together but they should show how your work is used or how it can be displayed.

These are not the requirements for good portfolio photos; therefore, although you may have wonderful portfolio shots, they may not all be usable in a catalog. A typical catalog shot of a block-printed tote bag would not emphasize the print but might show the bag being held, with a loaf of French bread or a book sticking out of the top.

Catalog photos are in a sense more businesslike than portfolio shots. Function and salability are stressed, and often several related pieces appear in the same photograph. I've suggested shooting photos for competition or portfolios against a simple solid-color background so that your work is the only thing that jurors and gallery owners see. When it comes to catalog photos, though, it might be important to show someone using your ironwork, wearing your jewelry, or displaying your batiks. However, it would certainly be appropriate (if there's room), to add to your catalog a picture from your portfolio showing you at work. Besides adding a personal touch, this shows your skill and care.

13

Getting Prints from Slides and Working through the Size and Texture Muddle

IDEALLY, every craftsperson will have a slide, color print, and black-and-white print of every craft object produced in the studio. That's ideal, but hardly practical. Fortunately, if most of your pictures are slides, you can convert them to prints. Once you've learned about conversion, I'll introduce you to the peculiarities of papers and print sizes so you can get the best buys when your conversions are printed.

BLACK-AND-WHITE PRINTS FROM SLIDES: DOING IT YOURSELF

You yourself can do the biggest part of converting slides to black and white, and of the three methods I'll be describing, only one requires a darkroom. Remember, though, that for each extra step the image goes through from positive to negative to positive, there is a loss of some sharpness and contrast, and an increase in grain.

Also, our eyes seem to accept a greater degree of softness in a color image than in a black-and-white one. So, whether you or a lab does the conversion, a black-and-white print may not be as sharp as the very sharp slide it came from.

If you have a darkroom and are fairly sophisticated in handling photographic materials, you can place the slide in your enlarger and project the image directly onto a piece of film.

A fine-grain sheet film measuring 4" x 5" or 5" x 7" works well. Kodak Commercial 6127 or 4127 sheet films can be used for this purpose, as well as Kodak Technical Pan 2415. The large negative you get will then produce excellent prints.

The other two methods don't require a darkroom, but do require that you take your black-and-white film to a processing lab.

The first method involves using a slide projector, which you may already own.

Photographing a projected image is an easy way to make a black-and-white negative of a color image. This requires projecting onto a flat white surface: beaded screens and lenticular screens won't work as well. A large poster board, a flat white wall, or similar surface works best. Put your camera on a tripod and set the lens to F/8. Use the camera's meter to get the correct shutter speed and, of course, bracket the exposures. The projector will provide all the light you'll need.

Here are some tips for success. Use a medium-speed film such as Kodak Plus-X or Ilford FP4. Try to keep both the slide projector and the camera perfectly horizontal and as nearly on the same level as possible. This will avoid distortion in the image. Since the lamp in the projector is a tungsten-quartz bulb it is warmer than daylight and is rich in red and yellow light. You might experiment with pale blue filters (an 82A for example) if the tones of your prints seem wrong. If the red areas in the image come out too light and blue areas too dark, try a filter.

The other non-darkroom method for converting color to black and white is to use a slide duplicator to produce a negative. These devices come in two different designs. The more expensive design is a box-shaped light source that has a solid base and a rigid metal column on which to mount your camera. These duplicating systems start at about $150, and professional outfits can cost several thousand dollars.

The other design is a device which mounts directly on the camera body. Usually these duplicators are metal tubes about ten inches long which have their own built-in lenses and a mechanism to hold a slide at one end. Such devices are available at prices ranging from about $30 to $150.

To use this second type of slide duplicator you load your camera with film (in this case try Plus-X or FP4), slip a slide into the slide holder, and point the whole thing at a light source like the sky or a bright light. Most slide holders have a white plastic diffuser which I find should *not* be used when you're using black-and-white film in the camera. The built-in lens has a fixed aperture, usually equivalent to about F/16, so you'll have to use the camera meter and the camera's shutter-speed control to get the correct exposure. Again, remember to bracket exposures.

Whether you use the slide projector or slide duplicator, the black-and-white film can be processed at a lab and you can get black-and-white prints directly from the negatives.

COLOR PRINTS FROM SLIDES

If you're having slides converted to color prints, and the prints are intended for a portfolio, it's important that you get the best-quality prints. You'll find it useful, therefore, to know something about color printing.

There are three types of color printing processes. Two — Type R and Cibachrome — produce color prints directly from slides. The third, Type C, requires that a color negative (an internegative) be made from your slide and the print made from that negative.

As to which type of color print to get, there is no simple answer. Each has certain advantages and certain drawbacks. Cibachrome prints are the most expensive. The prints are very brilliant, contrasty, and, because of the extremely stable dyes used in the print, they are long-lasting and fade-resistant. The Type R and Type C automated prints cost about half as much as the Cibachromes, even when custom prints are made.

The terms *automated* and *custom* prints need to be explained. Automated means not simply machine-produced, but printed to standard color balances which have been programmed into the color-printing machine. Usually there are only a few standard cropping masks to choose from and you can't get any corrective work like the lightening or darkening

of a specific part of the print. If the color produced by an automated machine is very bad most processors will do a second more correct print, but that's it.

Custom prints can be made on the same automated machines, but the lab will run several prints to get the correct color balance. They will even match the colors to a sample. Also, they will lighten areas of the print or darken them, and the print will be cropped, or cut, to your specifications. You can get automated and custom Cibachromes too. But the cost of *that* custom work is much higher.

Most color printers are good at matching and balancing skin tones and can make great portrait prints. But prints of crafts are more difficult because printers will not have a color referent to tell them what the colors of the object should look like. So they have to guess.

Even the original slide won't help because it will take on a slight cast depending upon the color of the light by which it is viewed. But including a standard object in the photo will help. If it is in a part of the frame which can later be cut out of the picture, so much the better.

In Chapter 6 I told you about the Kodak Color Patch Strip, which contains various standard colors and is used to help a printer. If you're not up for buying a strip you can use another Kodak standard which, surprisingly enough, is free. It's the Kodak film box itself. Kodak yellow is so common throughout the photographic industry that the box can be used as a cheap and convenient standard. It's perhaps not as superprofessional as the color scale but it works pretty well. Just put it in the margin of the picture, where it will be cropped out.

Type R prints are made directly from slides. Like the Cibachromes they are fairly contrasty and have intense colors. Type C prints, made from negatives, are less contrasty and the colors seem to have longer tonal scales, less pop but more range and sublety.

Which type should you choose?

It's a hard choice. It depends upon your work and your pocketbook. For example, if your work has bright colors you could choose Cibachrome to give those colors full range.

It may take some experimentation. You might want to get a type C, R, and Cibachrome of the same slide and compare them, for example, or you might have several labs print the same slide, the same way, to see how different labs deal with quality control.

Viewing color slides by the light passing through them is about the best way to see color. Even the most carefully made print won't match the brightness, color fidelity or color saturation of a slide. Keep that in mind when you go to get your prints. You will be looking at light reflected off a piece of paper and you need to understand the limits of color printing so you won't be disappointed by the lab's work.

GIMMICKS AND QUIRKS: PRINT SIZE AND TEXTURE

Paper texture and print size are two factors you must consider when ordering prints, and typically they are a pain to deal with, both for you and the lab.

Most amateur-oriented labs, and that includes Kodak, will print color images on paper with a textured surface. The worst type is somewhat tweedy. Some labs use a slightly better type that is a sparkly "silk" surface. These surfaces serve only one purpose — to cover up flaws. They are some marketing manager's gimmick that is supposed to make your family pictures more pleasing by covering up bad skin tone, slight lack of focus and other such problems.

Of course, these surfaces make it easier for labs to produce acceptable prints for customers, and that's their real purpose. But for any artistic or commercial purpose they are terrible. When you order prints, specify that you want glossy paper. Some people get matte, or flat, prints, but these are dull and lack the depth of good glossy prints. That's what you order, and don't get talked into selecting a matte, "silk," "luster," semiglossy, semimatte, "tweed," or "pearl" surface.

Print sizing is terribly confusing. For all of its high-tech aspirations, photography is rooted in some of the corniest drivel to come out of the Victorian era. Why we must be tethered to outdated Victorian concepts of picture sizes is a mystery to me.

There were people in those days who actually wrote essays arguing for a particular "perfect" print size. The result of all of their pseudo-scholarship is that film and print sizes today are a mess — misproportioned, mismatched.

A 35mm film frame is 24mm x 36mm (although even this may be slightly different with different cameras). This is a ratio of 1:1.5. If you take a 35mm slide to a lab or camera store to get a print you can choose the following sizes: 3 1/2" x 5", 5" x 7", 8" x 10", 11" x 14" or 16" x 20". But these sizes are in the following ratios: 1:1.4, 1:1.4, 1:1.25, 1:1.27, and 1:1.25. None matches the ratio of the 35mm slide. This means that if the picture is to fill the paper, part of the picture must be cut, or cropped, out. For 3 1/2" x 5" and 5" x 7" the loss is slight, but for the larger sizes it is more significant. This is important if you have carefully framed your picture when you took it. Your piece in a longish rectangle may make it look very different than it will look on a squarer print.

The problem originated in the sizes of the early sensitized photographic plates. Somehow these unrelated sizes have become cast in film-making concrete.

You can get your whole picture printed if you ask for a full-frame print, which, on standard paper sizes, means that there will be some blank paper on either side of the image (on Type R prints the borders will be black) and this may be acceptable to you. I find it inoffensive although it is a waste of paper.

Some labs offer full-frame prints on odd-size paper. You can get an 8" x 12" or an 11" x 16" and that's great, although it makes it harder to find frames or to include an 8" x 12" print in an 8 1/2" x 11" folder.

Other film sizes fare no better. Many photographers shoot medium- and large-format camera film sizes in addition to 35mm. You can get several different image sizes on 120mm film. With some cameras you get a square image 60mm on a side. It is a proportion which fits nothing, so it is marketed as offering the photographer the ability to crop both horizontal and vertical images out of the same frame. They also tell you how nice it is that you don't have to turn the camera

sideways to take a vertical picture. Who cares that the full image fits no known paper size?

Other image sizes can be made on 120mm film. One is 60mm x 45mm and another is 60mm x 70mm. The 60mm x 45mm is a proportion of 1:1.33 and the 60mm x 70mm is 1:1.16. Both closer to the available paper proportions, but no cigars.

Larger than the 120mm film is 4" x 5" cut film, which exactly fits 8" x 10" and 16" x 20" papers. The reason for this, of course, is that 4" x 5" and 8" x 10" are two of the original Victorian sizes and are the only part of the legacy that makes sense. There are 5" x 7" and 8" x 10" cameras as well, but they are usually found only in large studios and it is unlikely that you will encounter these film sizes.

There is no simple answer to the problem of film/print size. You must choose whether to crop some of the image or to have lots of unexposed paper around the image.

I'm enough of a traditionalist to prefer to print the whole frame. Since I frame as carefully as possible for the strongest impact that's the picture I want to retain.

I must even admit to a certain quirkiness, like the Victorians. Besides my 35mm camera, I have a 2 1/4" camera, which makes those square pictures on 120mm film that doesn't fit anything. And although it sometimes is a problem when making prints, I do take some pleasure in knowing that I don't have to turn my camera sideways to take verticals.

14

Camera and Slide Care

CLEANING A CAMERA

CLEANLINESS is essential to good photography. A lens that's covered with dirty fingerprints will not take sharp pictures, nor will a scratched slide help get you into a juried show. With a little care you can keep equipment and photographs clean and add years to their usefulness.

As a commercial photographer I'm pretty rough on my cameras and lenses so I have a regular schedule for cleaning and adjusting them. Usually after every major shoot I examine the lenses and the camera bodies. All of my lenses have ultraviolet (UV) or skylight (1A) filters on them so that if any surface gets dirty and scratched, it will be a filter, not the lens.

The UV is clear glass and the skylight is a pale pink, and neither makes a big change in the color of my pictures (they're meant to reduce the blue haze in landscapes) so I leave them on the lenses permanently. But they do get dirty and need to be cleaned.

The basic tools for cleaning cameras and lenses are a soft sable brush, a much-washed cotton handkerchief, cotton swabs, and that's all. I also have cans of compressed air, but the brush is my first choice for trying to remove dust from a surface.

While it is easy to brush and blow dust off a camera, lens, or filter, it can be more difficult to clean up fingerprints, sea spray, and grit. Cotton swabs can clean the small spaces between camera controls such as around the shutter-speed control and rewind knobs. You can also clean the insides of a

camera if you remember not to touch either the shutter curtain or the camera mirror. If your camera has interchangeable lenses you may find small bits of metal flecks in the mirror area. The compressed air or brush can clean these up.

Fingerprints on glass surfaces can be removed in several ways. I find that a little breath on the lens, followed by gently wiping the surface with a very soft well-washed cotton handkerchief does the trick. I avoid lens-cleaning fluid and never use tissue or eyeglass cleaner because they might scratch the lens or remove the coating.

CLEANING SLIDES

Cleaning slides and keeping them clean also requires attention. Here again the compressed air can easily clean off bits of dirt that may be adhering to the slide. Use the air first and if that fails try a gentle brushing of the surface.

Cans of compressed air sold under names like *Dust*Off* and *Airforce* can be effective for cleaning cameras and slides, but use caution. These cans contain fluorocarbons that may be affecting the ozone and, on a more immediate basis, have a tendency to spray fluorocarbon onto the lenses and slides. The scum this leaves behind can be harder to clean off than the original dirt.

Fingerprints on slides can be a problem. If the print is on the non-emulsion (shiny) side of the slide you can remove it by gently wiping the fingerprint off with a cotton swab that has been dipped in Kodak film cleaner. This cleaning fluid will remove the oily fingerprint and evaporate without leaving any residue.

Fingerprints on the emulsion side quickly become fingerprints *in* the emulsion as body oils eat into the image. It's a bad problem that can sometimes be solved if caught early enough. The trick is to soak the slide for several hours in a solution called Photo-Flo. Made by Kodak and several other manufacturers, Photo-Flo is used as the final rinse in film processing. It contains emulsifiers that break the surface tension of water and prevent water-spot marks as the film dries.

Soaking a transparency in diluted (as recommended) Photo-Flo can remove the oils from the fingerprint and save the slide. You will have to remove the slide from its mount, clean it, dry it and remount it. I usually air-dry the transparency by hanging it up in a dustfree area. I use a pulled-open paper clip, and hang the transparency by one of its sprocket holes. Most camera stores sell cardboard or plastic slide mounts with which you can easily remount the dried slide.

Wear cotton gloves when you remount the transparency (or hold it very carefully by the edges), since the last thing you want to do is to get a fingerprint back on it.

STORAGE AND LIFE EXPECTANCY OF SLIDES

Color film, with its many layers of chemicals and emulsions, needs tender loving care, which means careful storage.

As soon as I get transparencies back from the lab I put them into individual plastic protectors made by the Kimac Company (478 Longhill Road, Guilford, CT 06434). These clear plastic sleeves, which fit the mounted slides and absolutely protect them, come in 35mm, 2 1/4", and other sizes, and can be purchased at larger camera stores as well as from the manufacturer. With these sleeves on them, the slides will fit in slide trays and, generally, work in slide projectors although they do have a tendency not to drop easily into place.

The individually protected slides can then be stored in plastic slide pages, each of which holds twenty slides. These pages are usually punched so they can be stored in a loose-leaf binder or hanging file. Some types are made of PVC (polyvinylchloride) plastic, which can, under certain circumtances, cause chemical damage to the slides, so try to get pages which are not made of PVC. Slide pages made of polypropylene are one alternative, and are available from Franklin Distributors, Box 320, Denville, NJ 07834, among other sources.

There has been some question about the life expectancy of color slides. Although the topic is complex and tends to be discussed in terms of chemical technology, there are some common-sense points to help us through the problem of slide storage and image permanence.

First of all, color slides simply are not long-lasting. Everything seems to be destructive to color images. One report I've seen says that a twelve-minute projection in a normal 250- to 300-watt projector will seriously fade a slide. Imagine the abuse your slides get as they go from one jury to another (which is why I advise getting high-quality duplicate slides to send to juries.)

But let's say you never project a slide. You get them back from the lab or the photo shop and put them in a dark, cool, dry freezer at perhaps 0°C. What do you discover? Well, Ektachrome films may show up to a 10 percent loss in density of a dye layer in less than ten years. Films such as Kodachrome II and Kodachrome X may last twenty to fifty years, and the newer Kodachromes 25, 40 and 64 may last a bit over fifty years. But this is under optimum frozen conditions.

Clearly, the current state of the art in color-image stability is not very good. For your own work you can take the following precautions that may help maximize the life of your slides — understanding all the while that they may still not last long enough for your grandchildren to see:

- Use Kimacs for individual slide protection;
- Get duplicate slides for projection and display;
- Use non-PVC plastic slide pages;
- Store slide pages in stiff binders, standing vertically, or in hanging files;
- Never lay pages on top of each other because the weight of the pages can cause pressure marks in the emulsion;
- Store all slides in a cool, dark place with good air circulation.

I recommend two Eastman Kodak publications if you want to do more exploring regarding safe, long-lasting storage of your valuable slides: "Preservation of Photographs" (Publication F-30, $5.50), and "Storage and Care of Kodak Color Films" (Publication E-30, 25¢). Both are available from Dept. 454, Eastman Kodak Co., 343 State St., Rochester, NY 14640.

VIEWING SLIDES

The unique quality of a color transparency is its ability to record contrast. A well-done slide has "snap" to it, a brilliance which is best seen when light passes *through* it as opposed to when seen in reflected light.

Projecting a slide means that the light we see must be reflected off a screen, which lowers the contrast of the image. This loss occurs even under optimal conditions, as in a totally darkened room with a good screen.

Projecting also has the problem of projection lamps that operate very hot. That means their light is reddish. The reason slides don't appear reddish is because our eyes adapt and compensate for the color temperature of the light. That's why a table lamp seems to produce a white light even though it's not white. But adaptation is not color accuracy. When we view projected slides, the colors we see may be warmer than they are in real life. It's easy to perform a little test to see how powerful this effect is. Take a slide, stand near a window and turn on the room light. View the slide against the white of a cloud, then the blue sky, and finally the room light. Do this fairly rapidly and watch the colors change.

A light table or a table-top slide viewer offers a good way to see slides. With a light table you need a good-quality magnifying loupe to view the slides: you can get one at your local camera shop for under $20. My light table is a fluorescent fixture with a milky Plexiglas surface. I replaced the normal fluorescents with special daylight-balanced tubes and it works great and keeps the slides pretty cool.

When I juried slides accompanying fellowship applications, I had the luxury of time. I could go through the images again and again. Yet I never touched a single slide. And I never put a slide into a hot projector with a mechanical lever that too often could jam and fold the slides.

A light table allows me to view slides in their slide sheets or, if need be, to carefully slip a slide out of a sheet by its cardboard mount and view it. Too often craftspeople have their slides mishandled and mangled in the jury process. The answer

to this problem is not to send originals but to send duplicate slides (see the first section of Chaper 12).

Juries view slides projected on screens out of necessity and convenience. If you have several hundred applicants and three or four jurors with very limited screening time, it makes sense to project the images. But it is neither the best nor the safest way to view slides. It's just the most practical.

Did someone out there say, "No, Meltzer's got it wrong, the projected image is better because it's bigger"?

Sure, sometimes bigger is better, but not always. The issue really is "apparent size," and that means not how large the image is when projected but how large the object *seems*. From the last row of a big movie house, the space ships in even *Star Wars* feel small. From the first row they're overwhelming and too grainy and big.

A good-quality magnifying loupe on a table-top viewer allows you to see the slide in the same apparent size as, say, an 8″ x 10″ print held at arm's length or a 6′ x 4′ projected image seen from ten to fifteen feet away. Remember, too large an image and we see the fiim's grain, and the image loses contrast and sharpness.

So the best way to handle slides is to view them by transmitted light (coming through them) on either a table-top viewer or a light table with a loupe, and to always be extemely careful to hold the slides by their mounts and as little as possible.

For juries send high-quality duplicates and for yourself don't project your originals unless absolutely necessary.

15

Hiring a Photographer

THE whole point of this book is photographing your own work, but there may be occasions when you need to find a professional photographer. You might be having problems photographing particular pieces, or you might find that you need large or medium-format transparencies.

Juries want to see 35mm slides for judging shows. But for high-quality magazine and brochure use, larger-size transparencies may be preferable. Medium-format transparencies shot on 120-size film or larger do not require as much enlargement as 35mm slides and, in addition, they tend to print with greater clarity and color. Most craftpeople work with 35mm equipment, and it isn't practical to make the additional investment for the more expensive medium-format cameras. So if you need large negatives or slides, or this just isn't the time for you to do your own work, you will want to seek out a professional photographer.

FINDING THE RIGHT PERSON

When you need a photographer, look for one who is experienced in photographing crafts. Ask other craftspeople about photographers who've done work for them and with whom they've been satisfied.

When you contact a photographer, no matter whether personally recommended or found through the Yellow Pages, ask to see his or her portfolio. Good photographers enjoy showing their work because they know that quality work sells itself.

It is especially important to see how the photographer has handled crafts similar to your own. (If the photographer has no portfolio, look for someone else.)

Then talk to the photographer. In my experience, the more talented and the more professional a photographer is, the more accessible. You should be able to talk to photographers and explain what you want, and they should be able to explain whether it can be done or not. They should be able to make suggestions for lighting and backgrounds and you should be able to understand these ideas. People who assume the posture of the artiste and wrap their work in mystery should be avoided.

When you find a photographer who you feel will be right for you, specify exactly what you need. Be aware that when working with medium- and large-size transparencies, photographers do not shoot as many different shots as in 35mm work. There has to be more control and technical precision because the per-shot cost of film is much higher. An 8" x 10" sheet of color film — one picture — is just about the same number of square inches of film as an entire 36-exposure roll of slide film, and they cost about the same. So you need to decide what you want and let the photographer know exactly what that is.

COSTS

In your search for the right photographer you will learn that there are many different types of photographers: press photographers, studio photographers, advertising photographers, promotional photographers, and more. Each group has specific markets and its own pricing structure. And most will be able to photograph crafts — but with varying degrees of success.

All of these photographers have certain costs which they have to cover through their work: cameras, lenses, lights, backgrounds, rent and other studio overhead. Like a craft producer, a photographer is a small business person and has to pay federal, state, local, and Social Security taxes, buy insurance, maintain medical-dental coverage, and so on. These costs add up and are some of the things you are paying for as a

customer. Because of these costs the base-time charge asked by a photographer may seem high. But it isn't all take-home profit.

Prices will vary according to region, but you should be able to find a good studio photographer who will charge between $50 and $150 per hour to shoot. A large commercial studio that generally shoots for advertising clients may charge $300 an hour or more.

Photographers will usually charge expenses separately, and the bill you receive should show a cost for film, processing, and, when applicable, prints. These costs will not be low-cost drugstore-processing prices. A good photographer will use a good lab and that costs money. Photographers will also mark up film and processing costs to reflect their services. Someone has to get the film to a lab, and someone needs to do the paperwork. For example, you yourself, by doing the legwork, can get a 36-exposure roll of film and have it processed by a large-volume lab for perhaps $8. A professional photographer may bill you $25 for that same roll of film, custom-processed.

With these costs in mind you should be able to sit down with a photographer beforehand and get an estimate for the photo session. A professional photographer will know how long the work should take and will deliver the work on time and at the estimated cost plus or minus about 5 percent. And if you are not satisifed with the work you should have redress to a reshoot without additional time charges.

I have heard of several pricing structures that I would watch out for if I were you. A per-slide or per-picture price is one to avoid, simply because it makes little sense from the viewpoint of the photographer. It allows the photographer little leeway for extra effort, time or film.

Get a *job* price. And be wary of the photographer who charges you at the "going rate." There isn't any such thing that I know about, and even national organizations such as the American Society of Magazine Photographers have only *suggested* guidelines. It is common in those listings for the cost of a particular service to vary as much as 200 percent or more, depending upon who the photographer is and which part of the country you live in.

A photographer should have a rate sheet or other pricing information and should be willing to discuss how a price is set. Remember, professional photographers will treat you as a customer whose good will and willingness to spread the word about their service is important.

WHEN THE DEAL GOES SOUR

Suppose, after checking your bank account and doing some research, you took the big step and hired a professional to shoot your work for an important juried show. You open the envelope containing slides and out come half a dozen murky shots and a bill for half again as much as you expected. What can you do?

In most cases photographers work with their clients on the basis of oral contracts. Some photographers use written contracts (which you need to read carefully, of course, before signing), but in any event certain conditions apply.

Whether it's an oral contract or in writing, you agree to pay a photographer a specific amount for the service of photographing your work and supplying you with a specific minimum number of slides, prints, or negatives of professional quality.

The key words are "professional quality."

The photographer has given you a bid, a best-guess estimate of the cost of the photography. In some cases the photographer may simply state a flat fee for the work, which is fine too, except there can be some situations in which additional fees may apply. The photographer then agrees to provide the work you want at the stated cost.

But things can and do go wrong.

I'm a working photographer, not a lawyer, so I'll speak to what are, to me, basic business practices and not the legal conditions. (For the legal side of crafts, check out *The Law (In Plain English)*™ *For Craftspeople* and *Business Forms and Contracts (In Plain English)*™ *for Craftspeople* by Leonard D. DuBoff, both available through the publishers of this book. They cost $12.95 and $14.95 respectively.)

Professional-quality photographs will be sharp and clear, correctly exposed, and as color-accurate as possible. They will also present the objects photographed in a pleasing manner. Whenever I photograph craftwork, I also try, naturally, to produce photographs that are clearly going to please my clients. But you can't always please your clients, so I'll just say that factors such as clean white areas, good focus and lighting are the most objective criteria for judging photographs.

If you get back pictures that are sharp, clear, and bright, the photographer has basically fulfilled the contract and should be paid. But suppose you don't like a particular angle or the choice of lighting. Well, you can ask the photographer why those angles or lights were chosen, but you really don't have a lot of recourse, I feel, when you are dealing with concerns of style or taste. You should have considered the photographer's style and approach earlier.

But most photographers, like most small businesspeople, want to build good relations with clients. Good word-of-mouth is the best form of advertising, so it's in the photographer's own interest to keep you happy.

If the photos are well done but not exactly what you wanted, you may have to pay all or part of the cost of additional shooting.

But what if the pictures are barely acceptable or not acceptable at all? As far as I'm concerned, I don't expect to be paid for useless, substandard photographs. In fact, when I do a job, I usually ask my clients to leave with me the craftwork that I photographed long enough for the color film to be processed (a few days at most). Then, if the photographs are not up to my standards for minimum quality, I reshoot and I absorb the cost.

If the lab ruins the film — and even the best do on occasion — it's much more difficult to assign blame. A photographer may redo fairly straightforward studio shots for a partial fee or no fee, but if the original shoot required travel or complex location setups, you the client may have to pay the full cost of the reshoot.

If the photo-session cost is much higher than the photographer's bid or agreed price, there are several considerations.

First of all, whenever possible the photographer should get the client's approval for extra costs or unusual expenses that come up in a shoot. And that includes any situation when the shoot takes significantly longer than expected and time or rental fees are incurred. When a photographer first explains costs, ask what extra costs there might be . And ask for explanations of items. I've heard of "professionals" who billed their clients for rental of cameras and tripods! Unless your work requires some incredibly unusual piece of equipment, the photographer should already have all the gear necessary. You also should not be paying for flood lamps or backgrounds (unless you have asked for a specific and somewhat unusual color or type).

You should be satisfied by the work the photographer does for you. Not necessarily thrilled, but satisfied. Underexposed or overexposed photographs, color shots that are heavily color-cast, or physically damaged pictures do *not* satisfy any contract you've made with the photographer. With most professionals you should be able to agree to some kind of reshoot. But you do have the right to withhold payment until satisfactory work is provided.

If the deal has gone sour and you've paid a lot of money for unusable material, you've probably been misled and you haven't been dealing with a professional photographer.

Then it's time to find a professional lawyer.

16

Is Photography Becoming Extinct?

WHEN Daguerre's invention of photography was first presented to the French Academy of Sciences in 1839 one member of that assembly was moved to say, ". . . from this day forward, painting is dead!"

Well, painting didn't die and in fact in the next hundred years it blossomed.

Today there is a constant stream of new developments and inventions in photography, and occasionally one still hears echoes of that old academician's comment. Because of the proliferation of video equipment, specifically the new video still-camera technology, I've heard whispers lately about the death of photography as we know it.

Does this mean everything I've been teaching you about photography is obsolete? Or that we should all run out and buy video equipment to replace our 35mm cameras? Hardly.

Videotape technology is something we are all familiar with from both ordinary TV viewing and the mass marketing of home VCR (video cassette recording) systems. Videotape technology has successfully supplanted home movie equipment and is now the medium of choice, at least in America and Japan, for recording moving images of one's family.

Video equipment *is* used by business people and crafts-people. For instance, a video tour of a craft studio, or a music-and-video-style presentation featuring craftwork, can be an effective marketing tool. In these cases, however, videotape is an addition to photography, not a replacement. Still images

serve a very different purpose than moving ones. Today you can reasonably carry both a slide carousel and a videotape with you when you are out beating the bushes for business.

It is video still camera technology, however, which is seen as most "threatening" to the future of photography.

The video still camera is a hybrid that mixes the electronics of video with the still image of film. Manufacturers have always felt that consumers want instant gratification, so a great deal of research and development has been expended on finding faster ways of seeing pictures. That's not a new idea: even Daguerre thought that photography could be best used to give artists "instant" records to paint from so that they wouldn't have to worry about, say, bad weather.

At any rate, Sony sent a photographer to the 1984 Olympics in Los Angeles with a prototype video still camera. The pictures were transmitted electronically to Japan and the color hard copies (photos) were printed in the daily newspapers. The pictures were coarse and without much detail, but they were usable, and that was seen as a major demonstration of the system's feasibility. Maybe.

Video still cameras, which only exist in prototypes so far, are about the size and shape of old Super-8 movie cameras. The camera lens focuses an image on a sensor cell made up of thousands of individually wired *pixels* (from picture elements).

Each pixel, like the dots in a newspaper photo, is a point of information recording the color and intensity of the light falling upon it. This information is recorded electronically on a small 47mm floppy disk, similar to a computer floppy disk, that can be played back through a player and TV monitor.

A sensor with at least 300,000 pixels is needed for a moderately useful image, but so far most prototypes have only 180,000 pixels. Over the horizon, technology promises sensors with 1 million pixels. That will produce a fine image on a TV screen, almost twice the quality we have now in American commercial broadcasting, but it still produces a mighty coarse photographic print.

Remember, photographic film has picture elements which are tiny clusters of silver molecules. A 35mm slide can be

projected to an image of 30″ x 40,″ and we will barely see the film grain. Electronic video still-camera technology may simply never be able to equal this level of sharpness and clarity.

So maybe the rumors about the death of photography are a bit premature, especially since consumers are a very fickle lot. The last decade alone is littered with technological advances that no one cared for at all. Polaroid's instant Polavision movies were to have revolutionized home movie-making, but they quietly faded away. And what happened to the LaserDiscs: indestructible video discs that used laser beams and would last forever? They're gone.

The list goes on. Perhaps it's best to remember that new technologies never destroy useful and practical inventions or art forms, such as photography and painting. They just expand them.

So get that 35mm camera you want. It's okay.

Is video equipment replacing still photography? Not now — and it never will until it can meet the sharpness of pictures such as this close-up of an Uncle Sam whirligig by woodcarver David Lesser.

COLOR FILMS (35MM AND 120)

Speed Group	Color Slide Film	Color Print Film	Comments
Slow films: ASA/ ISO below 100	Agfachrome 50 Agfachrome 100 Ektachrome 64 Ektachrome 100* Fujichrome 50 Fujichrome 100 Kodachrome 25* Kodachrome 64*	Agfacolor 100 Fujicolor 100 Kodacolor 100	Extremely fine-grain films, excellent for craft photography. Fujichrome is my personal film of choice.
	Kodachrome 40T Fujichrome 64T		For use with clear tugsten and quartz floodlights.
Medium-speed films: ASA/ISO 125-320	Ektachrome 200* Kodachrome 200*	Agfacolor 200 Fujicolor 200 Kodacolor 200 Vericolor III	Fine-grain films offering a compromise between speed and grain. Usable for crafts
	Ektachrome 160T*		Higher-speed color film for use with tungsten or quartz lamps.
High-speed films: ASA/ISO above 400	Agfachrome 1000 Fujichrome 400 Fujichrome 1000 Ektachrome 400* Ektachrome 400/800P*	Agfacolor 400 Agfacolor 1000 Fujicolor 400 Kodacolor 400	Fairly grainy films that are not of much help for photographing objects but work well for available-light documentation such as a fair, gallery, or show.

*These are also available in professional packages, which are the same film but require refrigeration until use and then must be processed immediately.

COLOR CONVERSION FILTERS FOR COLOR FILMS

	Daylight	Blue flash	Electronic flash	Photo lamps	Tungsten
Ektachrome 160 (Tungsten)	85B	85B	85B	81A	None
Ektachrome Infrared	12 or 15	12 or 15	12 or 15	12 or 15 plus CC50C-2	—
Kodachrome 40 5070 (Type A)	85	85	85	None	82A
Kodachrome 25 (Daylight) Kodachrome 64 (Daylight) Ektachrome 64 (Daylight) Ektachrome 200 (Daylight) Ektachrome 400 (Daylight) Kodacolor II Kodacolor 400*	None	None	None, unless pictures always tend to be blue. Then use an 81B.	80B	80A

*For especially important work

FILTERS FOR BLACK-AND-WHITE FILMS

Color of subject	Filter that lightens the color	Filter that darkens the color
green	yellow, green or orange	red or blue
blue-green	blue or green	red, yellow, or orange
blue	blue	red, yellow, or orange
yellow	yellow, green, orange or red	blue
orange	yellow, orange or red	green or blue
red	red	blue or green
purple	blue	green
pink	red	green
brown	orange or red	blue

TROUBLESHOOTING GUIDE

This troubleshooting guide describes the kinds of problems you might encounter in your slides and prints. Because color slides are made from the film itself, cut up and mounted, it's easier to see problems like exposure errors or color shifts on slides. Color-print and black-and-white films produce negatives, and when prints are made from these negatives many errors can be corrected. You will be able to see which errors go with which type of film.

If the photograph is:	Problem	Cause	Remedy
NOT SHARP Blurred	Camera motion	Camera was bumped during long exposure or shaken during hand-held exposure of more than 1/30 second	Use a tripod or similar support and a cable release
Out of focus over-all A very out-of-focus area surrounding a sharp area	Misfocus Shallow depth of field	Lens elements out of alignment Lens not stopped down to a small enough opening for good sharpness	Have lens checked Use aperture settings of F/5.6 or smaller for flat art and F/11 for three dimensional work
STREAKED Thin line along length of frame	Scratched film	Dirt on the felt of film-cartridge light trap or on camera surfaces that film runs along	Keep cartridges in plastic containers they come in and handle them carefully Clean camera interior with compressed air every once in a while
Clear or colored driplike lines and amoebalike forms	Chemical stains	Improper processing	If problem persists, change labs
Vertical streaks of bright yellow and red	Light flashes	Film loaded in bright light, exposing film ends through felt light trap	Always load film in subdued light

If the photograph is:	Problem	Cause	Remedy
TOO DARK All colors too dark White colors muddy Colors lack richness, show no real black (in color prints)	Underexposure	Incorrect exposure	Take careful exposure readings • Use grey card and bracket exposures • Check ASA/ISO setting on camera meter If all frames are consistently too dark, meter or camera shutter may need servicing
Deep blue slides Colors dark but washed out	Underdevelopment	Incorrect processing	If problem persists, change labs
TOO LIGHT Colors light, washed out, with whites and light colors merging No real blacks	Overexposure Overdevelopment	Incorrect exposure Incorrect Processing	See above
DEEPLY OFF COLOR Overall bluishness Overall reddish or yellowish color	Color balance	Mismatch of film type and lighting	Check that you are using film marked "Daylight" with out- door daylight, electronic flash, or blue floodlights, and are using tungsten-balanced film with clear floodlamps or quartz lights
SLIGHTLY OFF COLOR Pale pink or green color over all	Film's age	Slide film was too new (pink) or too old (green). Or badly stored and allowed to get too hot before use.	Use professional film for critical work Refrigerate film (at below 55°F)
Pale brown or blue in white or light areas	Light intensity	Slight underexposure due to reciprocity failure	Read film instructions and generally avoid exposures of longer than 1/8 second with color film and 1/2 second with black-and-white film

Glossary

The American language is highly flexible and constantly seems to be changing as new words and meanings slip into common usage. Photography abounds with jargon. Words like "shot" and "shoot" mean one thing to a photographer and an entirely different (and more ominous) thing to a police officer.

The following list of professional terms, acronyms, and abbreviations is offered as a small bit of light in the area of pop-tech photography newspeak.

AA and *AAA*. Battery sizes often used in cameras and flashes.

AE. Auto exposure, usually a setting that allows the camera's light-sensitive exposure system to electronically set the aperture and/or shutter speeds for an exposure.

AF. Auto focus, usually a mechanized focusing system found on small compact cameras.

Aperture. The lens opening. The size of the aperture determines how much light will pass through the lens. Apertures are marked in a sequence known as F stops: F/2, F/2.8, F/4, F/5.6, F/8, F/11, F/16, and F/22. The larger the F number, the smaller the aperture and the amount of light entering.

ASA. American Standards Association. ASA numbers indicate film speeds, but they are gradually being replaced by ASA/ISO numbers, which will eventually simply be ISO numbers. (ISO stands for the International Standards Organization.) The larger the ASA/ISO number, the more sensitive the film is to light; a film with an ASA/ISO of 200 is twice as sensitive to light as a film with an ASA/ISO of 100.

Balanced. Manufactured for use with a specific light source: daylight or tungsten. (See Color balance.)

B-bulb. The setting on the shutter-speed dial that keeps the shutter open for as long as the shutter-release button is depressed. This allows for exposures of more than one second.

(To) bounce light. To reflect the light source off a surface in order to diffuse or soften the light.

Bracketing. Making exposures not only at the meter-recommended shutter speed/aperture setting but also at one or two stops more and less exposure to insure properly exposed pictures despite difficult lighting situations or camera/film problems.

Cable release. A flexible tubelike accessory that usually screws into the camera's shutter-release button and reduces the risk of the camera being jarred during the exposure.

Cobra head flash. A separate flash unit. Shaped like an upside-down *L*, this head — in most cases — offers the advantage of adjustability; it can be pointed in any direction to bounce light.

Color balance. The temperature of light that a particular color film should be used with. Most film is *daylight* balanced for use with blue floodlights, electronic flashes, or daylight. Some film, designated with a *T* after the film-speed number, is balanced for tungsten light and so must be used with clear floodlights or quartz lights. With this film, acceptable results can also be obtained with normal household lamps.

Color shift. Any variation in a color print or transparency away from the color actually photographed. It may be caused by improper exposure, mismatching of film to lights, or incorrect film development.

Cropping. Cutting off part of the original image to get a stronger picture.

Daylight balanced. See Balanced.

Depth of field. The area of sharpness behind and in front of the object being photographed. Depth of field is of special concern for close-up shots, since part of an object or group of objects can be out of focus if the photographer forgets to keep depth of field in mind. Three factors affect depth of field: the aperture, distance focused upon, the focal length of the lens.

Depth of field *increases* when the lens aperture is reduced (for instance, stopped down from F/4 to F/11), or when the subject is moved further from the camera, or when a wider-angle lens (with a shorter focal length such as 35mm or 28mm) is used.

Depth of field *decreases* when the lens aperture is increased (say from F/8 to F/2.8), or the subject is moved closer to the camera, or longer lenses (such as 100mm or 200mm) are used.

See Chapter 3.

Depth-of-field scale. The markings on the lens, usually near or around the focus mark, that can be used to estimate the depth of field at any focal point and aperture setting.

Electronic flash or strobe. An electric device that produces a bright, very brief, burst of repeatable daylight-balanced light.

Exposure. Technically, the amount of radiant energy needed to expose a film. A formula for determining the correct exposure is the intensity of light multiplied by the amount of time the film receives the light: $E = I \times T$. The intensity of light (controlled by the aperture) that is correct for the time (which is set by the shutter) will produce a negative or transparency of the right exposure — that is, with the best possible tonal range.

Exposure meter. An electrical measuring device, often built into a camera, that "reads" the light and indicates on a dial the correct combination of aperture and shutter settings for that light.

F stops. Aperture sizes marked on the lens in a standard series: F/1, F/1.4, F/2, F/2.8, F/4, F/5.6, F/8, F/11, F/16, and F/22. Each stop allows half or twice the intensity of light to reach the film as the adjacent aperture. The *larger* the aperture number, the *smaller* the lens opening and the less light reaching the film.

Film format. A means of describing a camera according to the size of film the camera uses. A 35mm camera uses 35mm film; a medium-format camera, 120mm film; a large-format camera, 5" x 7" film or larger.

Film speed. A film's sensitivity to light, measured by ASA/ISO numbers. Typical film speeds are 25, 64, 100, 200, 400, and 1000. The larger the number, the faster and more sensitive to light the film is. As film speed increases, so do grain and contrast. A camera's exposure meter *must* be set to the correct film speed before exposure readings are taken and photographs shot.

Filter. A glass element in a threaded ring that can be screwed into the front of the camera lens. Filters may be lightly or deeply colored, or manufactured to produce special-effect images.

Flashes. Usually small electronic strobes, hand-held or built into the camera, that allow sharp, color-balanced pictures in low light. Although initally more costly than tungsten floodlights, flashes offer long working lives of color-consistent picture-taking.

Flash synchronization. The fastest shutter-speed setting that allows the shutter to be fully open in time for the very brief, bright exposure of a flash. This setting is usually marked on the shutter-speed dial by an *X* or a colored number. On most cameras this is 1/60 or 1/125 second.

Floodlights. Large tungsten lamps of 250, 500, or 1000 watts which, although usable for craft photography, have short lives (eight hours or so) and then shift color drastically.

Focal length. The approximate distance from the rear of the lens (a theoretical point usually just behind the aperture) to the film. See also Lenses.

Full-frame print. A print made from a negative in which no part of the photographic image is cut off.

Grain. The plague of most photography; speckling in a film. Grain is seen most clearly in large areas of uniform tone and is related to clusters of silver in the film emulsion. The faster the film the more pronounced the grain and speckling. For large enlargements or juried show slides, slow film with extremely fine grain should be used.

Guide number. An old system for determining the exposure when a flash is being used. The guide number divided by the distance to the subject gives the approximate correct aperture setting.

Hand-held. A camera used without a tripod or other support. A good rule of thumb is that you can generally hand-hold successfully if the shutter-speed setting is 1/lens focal length or faster. A "normal" 50mm lens can be used at 1/60 second or faster while a 105mm lens needs 1/125 (the closest setting to 1/105).

Incident light meter. A meter that reads the amount of light *falling on* the object rather than the light reflected off it. The meter (which is not usually built into the camera) is held near the subject and pointed at the camera.

ISO. See ASA.

Lenses.

Macro lens. A lens with a special focusing mount that allows the lens to focus within a few inches of an object. Useful for photographing tiny objects.

Normal lens. A lens whose focal length is about equal to the diagonal measure of the film-format frame. A 35mm frame is about 24mm x 36mm and has a diagonal of about 43mm, so a 45mm or 50mm lens is "normal" for this format.

Telephoto lens. A lens that serves as a camera's telescope, bringing distant objects nearer to the photographer. A telephoto lens has a focal length longer than the diagonal measurement of the film-format frame. In 35mm photography, telephoto lenses are 100mm or longer.

Wide-angle lens. A lens used to widen a view. A wide-angle lens has a focal length that is less than the diagonal measure of the film-frame format. In 35mm photography this term is used for lenses with focal lengths of 35mm or less.

Zoom lens. A lens made with movable elements that has a *variable* focal length so that it can function as a macro, a normal, or a telephoto lens. Typical zoom lenses range from 35mm to 75mm or from 80mm to 210mm.

Macro lens. See above.

Normal lens. See above.

Monopod. A one-legged support that serves as a rigid platform for a camera. These are usually used for outdoor work.

Open up. See Stop down.

Overdeveloped. Given too much development so that the resulting photo is "washed out" and unnaturally light.

Parallax. The difference in what is seen from two different locations. This is of concern to photographers because what the lens sees and what the photographer sees if using a rangefinder camera will be different. For close photography this could mean that something important would be cut out of the picture. The solution is to use a single-lens reflex camera so that the photographer sees exactly what the lens sees.

Quartz lights. High-intensity 500- or 1000-watt lights for use in studios, to be used with tungsten-balanced film.

Rangefinder camera. A camera with separate viewfinder that is located near the picture-taking lens but does not see exactly what the lens sees. These cameras are excellent for many purposes, particularly photojournalism, but because the viewfinder and lens do not see an identical view, these cameras make accurate framing difficult at close distances and thus they are not ideal for craft photography. See Parallax.

Reciprocity failure. A problem in film emulsion where the relationship between exposure time and light intensity breaks down.

Reflected light meter. An exposure meter that reads the amount of light reflected *from* the subject toward the meter, as opposed to the incident light meter, which reads the light falling *on* the object. Reflected light meters, although available separately, are usually built into cameras. See also Incident light meter.

Reflex camera. See Single-lens reflex camera.

Reflector. The metal hemisphere around the light source used to direct light in a specific direction.

Saturated colors. Deep, rich colors.

Shutter. An electronically or mechanically controlled clockwork mechanism that allows light to reach the film for a fixed amount of time

Shutter-speed settings. Settings marked on the dial that controls the amount of time the shutter is open to allow light to reach the film. The settings are a standard set of numbers representing the denominator in fractions (1/time); 1 for one second; 2 for 1/2 second; 4 for 1/4 second, and, similarly, 8, 15, 30, 60, 125, 150, 500, 1000. Each shutter speed is in effect one-half or twice the adjacent setting.

Single-lens reflex camera. A camera with a mirror/prism system that allows the photographer to see exactly what will be projected onto the film at the moment of exposure. This allows very accurate focusing and framing.

Stop down. The process of decreasing aperture. A stop is a unit of lens-aperture change. To stop down (by increasing the F number) is to reduce the amount of light that will reach the film. For example, you might stop down from F/2.8 to F/4. See also Aperture and F stops.

Telephoto lens. See Lenses.

35mm. A film format commonly measuring 24mm by 36mm. Other format sizes are 60mm x 45mm, 60mm x 70mm, 60mm x 90mm (medium formats usually on 120 film); and 4" x 5", 5" x 7", 8" x 10" (large formats usually shot on film sheets rather than rolls).

Tone. A measure of the intensity of color.

Transmitted light. Light passing *through* (rather than being reflected from) an object.

Tripod. A three-legged device that serves as a rigid platform for a camera. The legs usually are collapsible or can be adjusted for height.

Twin-lens reflex camera. A camera with two lenses, one above the other. The upper lens is for viewfinding and, through a complex coupling system, focuses the lower, picture-taking lens.

View camera. A larger camera usually found in professional studios that usually produces negatives or transparencies 4" x 5" or larger for high-quality magazine reproduction.

Wide-angle lens. See Lenses.

Zoom lens. See Lenses.

A FEW SOURCES OF FILM, CAMERAS, AND OTHER EQUIPMENT

Agfa-Gevaert Inc.
275 North Street
Teterboro, N.J. 07608

AIC Photo
168 Glen Cove Road
Carle Place, N.Y. 11514

Berkey Marketing Co.
25-20 Bklyn-Queens Expwy W.
Woodside, N.Y. 11377

Beseler Photo Marketing Co.
8 Fernwood Road
Fordham Park, N.J. 07932

Bogen Photo Corp.
100 S. Van Brunt St.
Englewood, N.J. 07631

Canon USA
1 Canon Plaza
Lake Success, N.Y. 11042

Chimera
P.O. Box 9
Silver Plume, CO 80476

Chinon U.S.A.
43 Fadem Rd.
Springfield, N.J. 07081

Copal Corp. of America
58-25 Queens Blvd.
Woodside, N.Y. 11377

Davis and Sanford Co.
24 Pleasant St.
New Rochelle, N.Y. 10802

Durst North America
641 South Rockford Dr.
Tempe, AZ 85281

Eastman Kodak
343 State St.
Rochester, N.Y. 14650

Falcon Safety Products
1065 Bristol Road
Mountainside, N.J. 07092

Fuji Photo Film USA
350 Fifth Ave.
New York, N.Y. 10018

Franklin Distributors
Box 320
Denville, NJ 07834

Hasselblad Inc.
10 Madison Rd.
Fairfield, N.J. 07060

Ilford
West 70 Century Rd.
Paramus, N.J. 07652

Kimac Company
478 Longhill Rd.
Guilford, CT 06434

Larson Enterprises
P.O. Box 8705
Fountain Valley, CA 92728

Leitz
24 Link Drive
Rockleigh, N.J. 07647

Minolta
101 Williams Drive
Ramsey, N.J. 07446

Nikon Inc.
623 Stewart Ave.
Garden City, N.Y. 11530

Olympus Camera
Crossways Park
Woodbury, N.Y. 11797

Pentax Corp.
35 Inverness Drive East
Englewood, CO 80112

Polaroid Corp.
549 Technology Square
Cambridge, MA 02139

Sugra Photosystems
3045 Liberty Ave.
Pittsburgh, PA 15216-8051

Tamron Industries
24 Valley Road
Port Washington, N.Y. 11050

Three-M Corp.
3M Center, P.O. Box 33600
St. Paul, MN 55144

Tiffen Mfg.
90 Oser Ave.
Hauppauge, N.Y. 11787

Unicolor
7200 Huron River Dr.
Dexter, MI 48130

Vivitar
P.O. Box 2100
Santa Monica, CA 90406

Yashica Inc.
411 Sette Drive
Paramus, N.J. 07652

Index